Charles Sheeler

and the Cult of the Machine

Charles Sheeler
and the Cult of the Machine

Karen Lucic

Harvard University Press

Cambridge, Massachusetts 1991

First published in the United States of America in 1991 by
Harvard University Press, Cambridge, Massachusetts

Published in Great Britain in 1991 by Reaktion Books, London

Printed in Great Britain
10 9 8 7 6 5 4 3 2 1

This book is printed on 130gsm Fineblade Smooth, an acid free stock
made from 100% chemical woodpulp, and its materials have been
chosen for strength and durability.

An extract from the following work has been reproduced
with permission of the publishers:
William Carlos Williams: *Collected Poems of William Carlos
Williams: 1909–1939, vol. I.* Copyright 1938 by New Directions
Publishing Corporation. Reprinted by permission of New Directions
Publishing Corporation.

Library of Congress Cataloging-in-Publication Data
Lucic, Karen, 1950–
 Charles Sheeler and the cult of the machine / Karen Lucic.
 p. cm.
 Includes bibliographical references.
 ISBN 0-674-11110-9 (alk. paper). – ISBN 0-674-11111-7 (pbk.)
 1. Sheeler, Charles, 1883–1965 – Criticism and interpretation.
2. Precisionism – United States. 3. Machines in art. I. Title.
ND237.S47L8 1991
759.13 – dc20 90-28893
 CIP

Contents

Acknowledgements

In my research on Charles Sheeler, which now spans almost a decade, many individuals and institutions have provided invaluable assistance. To name all of them here is not possible, but a few must be gratefully acknowledged. This book owes its genesis to the kind intervention of Margaretta Lovell. My dissertation adviser, Jules David Prown, provided essential mentorship over the years, especially in methodological matters. Wanda Corn first ignited my interest in the cultural nationalism of the early twentieth century, and later discussions with her on these and related issues have been immensely helpful. Cécile Whiting gave me rigorously insightful comments on the text, and the final version benefits greatly from her responses. Theodore E. Stebbins Jr, Patricia Kane, Carol Troyen and Erica Hirshler were very generous in their assistance. Vanessa Bennett and Monica Koenig helped prepare the manuscript, and Monica drafted an early version of the chronology. Nicholas DeMarco aided in obtaining photographs. The Research Committee at Vassar College awarded me a grant from the Salmon Fund. Finally, my most heartfelt thanks go to Douglas Winblad for his boundless encouragement and enthusiasm.

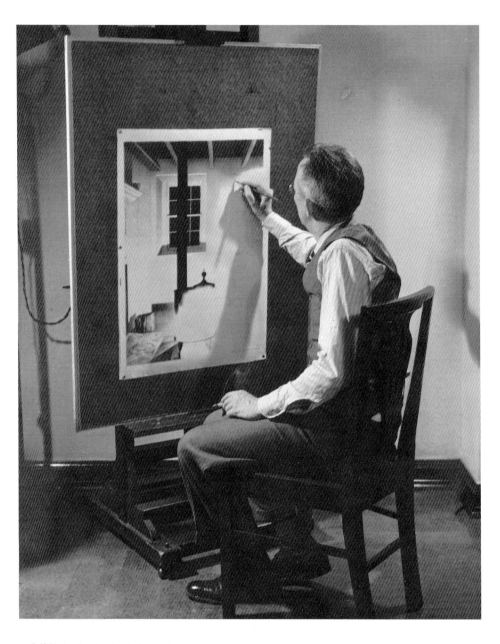

1 *Self-Portrait at Easel*, photograph, 1932

Introduction

Charles Sheeler, like many artists, writers and intellectuals of his generation, looked to the machine as the premier symbol of his era. During the years between the world wars, the products of rationalized industrial production – grandiose factory complexes, proliferating mass-produced goods, and towering, steel-framed skyscrapers – seemed to represent modernity in its very essence. The intense concentration on the manifestations and character of the machine age approached the dimensions of a cult. Indeed, many spoke of the machine as the new religion of the twentieth century. But while most agreed that it was *the* force with which to reckon during the era, there was also constant debate about whether its impact was for good or ill. In fact, artists and writers often exhibited a conscious or unconscious estrangement from the machine while simultaneously formulating new modes of creative expression to convey its symbolic power. America seemed to worship at its altar, but even the most adamant converts sometimes betrayed ambivalence and doubt.

From the 1910s through the 1930s, artists all over the Western world simultaneously evolved new aesthetic programmes in order to express the potent symbolism of the machine. These modes of pictorial representation attempted to convey the very essence of machine-crafted forms, but the resulting 'machine aesthetic' in painting and photography never consisted of a completely homogeneous set of stylistic features. Variations occurred from one national school to another and even among individual artists in the same country.[1] As Meyer Schapiro commented in 1937:

> In Detroit, the murals of machines by Rivera are realistic images of the factory as a world operated by workers; in Paris, Léger decomposes the element of machines into Cubist abstractions or assimilates living things to the typical rigid shapes of machines; the Dadaists improvise a whimsical burlesque with robots. . . . And the Futurists, in distinction from all these, try to recapture the phenomenal aspect of moving mechanisms, of energy and speed.[2]

9

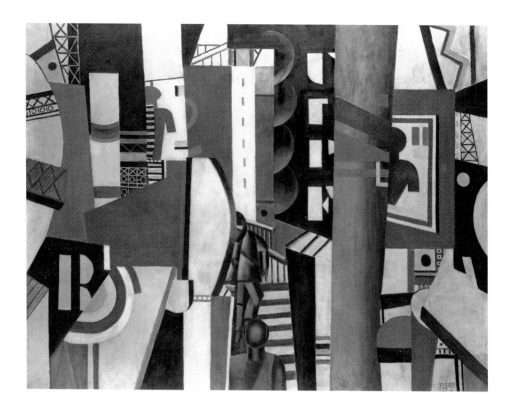

These differences indicate a variety of contrasting and sometimes conflicting concerns, largely influenced by circumstances that varied from country to country and from individual to individual.

2 Fernand Léger, *The City*, oil, 1919–20

Despite the artists' differing aims and attitudes, some stylistic continuities nevertheless appear in the various manifestations of the machine aesthetic. As in Fernand Léger's *The City* (illus. 2), hard-edged, geometric shapes predominate. In such works, these shapes delineate, either realistically or through diagrammatic abstractions, machine parts and architectural forms. Such forms appear in repetitive and often complex patterns, suggesting essential features of mass production and modern engineering. Almost all of these images locate the machine in a denatured world; organic motifs rarely appear.

Depending on the artists' perspectives and intentions, however, these forms could appear as either stunningly seductive or subtly threatening. The abstract, iconic works produced by De Stijl, Purist, Bauhaus, and Russian Constructivist artists

transform the machine into a utopian model for efficient and forward-looking social engineering. As the Bauhaus artist Lázló Moholy-Nagy declared in 1922, the 'reality of our century is *technology* – the invention, construction and maintenance of the machine. To be a user of machines is to be of the spirit of this century. It has replaced the transcendental spiritualism of past eras.'[3] In contrast, Dada and Surrealist artists created rickety, toy-like mechanomorphs, such as in Francis Picabia's *Universal Prostitution* (illus. 3). These works satirize the machine, and by extension, contemporary society's fetishization of it. Like the utopian-minded artists, Dadaists and Surrealists saw the machine as a force that dominates the modern world, but they fundamentally differed in their view of its control over contemporary life.

Such diverse attitudes and approaches to machine-age subjects indicate a conflict inherent in aesthetic practice at the time. On the one hand, the artists who developed machine-inspired styles were committed to constant stylistic experimentation and innovation. Although often aiming to create a 'universal' mode of expression, they nevertheless each evolved a recognizable signature style that was intimately tied

3 Francis Picabia,
*Universal
Prostitution,*
oil and ink,
1916–17

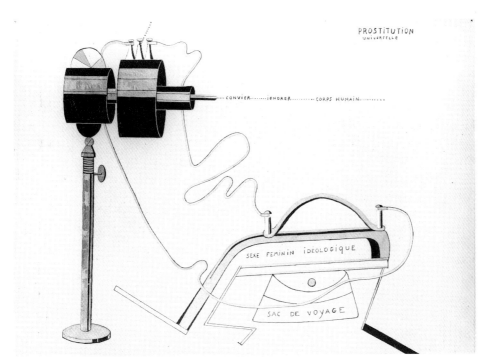

to their individual identities. An attentive viewer would never mistake a Léger work for one by Moholy-Nagy, for example; although both would appear depersonalized to a great extent, each work would still bear a distinctive mark of the maker's originality. Such personalized, innovative characteristics signal the influence of liberal humanist values; they assert, if obliquely, the traditional regard in modern Western culture for individual self-definition and autonomy. On the other hand, the subjects of these artists' concerns – mass production and modern engineering – suggest quite opposite associations: communal standardization, anonymity and a heavily monitored work regimen that disallows personal, idiosyncratic expression.

These conflicting levels of associational significance raise a variety of fundamental questions. Did the artists of the machine age successfully maintain a view of the creative self as free and autonomous while simultaneously adopting subjects associated with mechanical repetition and depersonalization? Does any uneasiness appear in their art as a result of this conflict, any evidence of fear regarding the reduced role of personal expression in the machine-dominated world they depicted? These questions indeed reveal basic contradictions in the modern artist's embrace of the machine during this era – an issue that will reappear in a variety of guises throughout this essay.

In post-World War I America, the most technologically sophisticated society in the world, these conflicts were particularly acute. American artists developed a national variant of the machine aesthetic (never a school or movement per se), which has come to be known as Precisionism or Cubist-Realism.[4] This American variant was a synthesis of realism and Cubist-inspired abstraction, which conformed to traditional norms of representation more closely than most manifestations of the machine aesthetic in Europe. Although unsympathetic critics have derided this art for its literal specificity, it eloquently expresses through easily recognizable iconography the cultural ambitions and conflicts that characterize the era. On the one hand, these works seem to celebrate the machine as a sign of America's international hegemony in the industrial sphere. But on the other, they also reveal signs of anxiety about the threats to a humanist definition of artistic identity in the machine age.

In this regard, Charles Sheeler's work is exemplary. In his paintings and photographs depicting New York skyscrapers, machine-dominated interiors, and automobile factories, Sheeler established his reputation as a major artist during this period. Although he was not the first American modernist to embrace the iconography of the machine, he produced images of extraordinary aesthetic power that also provocatively invoked America's well-established technological and industrial prestige. Through these highly-charged subjects and powerful presentations, he successfully communicated to a wide audience a sense of national identity based on machine production and urban grandeur.

In both subject and style, his paintings and photographs epitomize the ambivalent fascination with machine forms that emerged during the post-war era. In the monumental *Classic Landscape* (illus. 37), for example, the artist depicts a complex of industrial buildings at Henry Ford's automobile factory on the River Rouge near Detroit.[5] On the right, dynamically receding railroad tracks lead to a white-and-tan building with a reddish, bellowing smokestack. Large piles of sand occupy the foreground to the left, while the golden silos of a cement factory – suggesting an austere doric temple – claim the middle of the composition. The sky, filled with clouds and smoke, shares the same blond hues as the rest of the painting. In a landscape wholly dominated by the machine, the vastness of space and the extensiveness of the buildings suggest the immense productive potential of the industrial environment.

Although Sheeler renders each form distinctly, almost hyperrealistically, the painting's composition exhibits a simple geometric structure and demonstrates the synthesis of realism and abstraction characteristic of American versions of the machine aesthetic. Repetitive, columnar shapes represent the silos of the cement plant; simple rectangles and triangles form the building with the smokestack. The elevated railroad tracks delineate assertive diagonals that in themselves create tension and drama. Despite this indication of dynamic motion, however, the depopulated scene appears oddly static – solemn and classically ordered, as the title of the painting suggests. Sheeler's invocation of the golden age of antiquity bestows a fundamental aesthetic authority on these functional forms and asserts their permanence, stability, and an elevated status comparable to that of a Greek temple.

Such a presentation indicates an attitude on the part of the artist almost akin to religious awe. Sheeler's statements on the machine age are rare, but the few that do exist have helped create a public persona that seems to promote American industry unequivocally. For example, Constance Rourke – in her biography of the artist published in 1938 – quotes Sheeler as declaring: 'Industry concerns the greatest numbers – it may be true, as has been said, that our factories are our substitute for religious expression.'[6]

Nevertheless, there are troubling features in *Classic Landscape*, despite Sheeler's assertion of industry's centrality in the modern era. The stark factory complex has completely enveloped the natural landscape; the polluting smoke threatens to obliterate the clouds and sky; and the bleached, frozen scene is haunted with a sense of human absence. How, therefore, are we to interpret the apparent contrast between stated beliefs and the implications of the painting itself?

Throughout this study, we will ponder such questions in an attempt to understand the role Sheeler played in the cult of the machine. Was he a high priest or a heretic? These questions, however, will remain difficult to answer. Our estimation of Sheeler's relationship to the machine age shifts depending on the context in which we examine his art and life. Considered in terms of his reception, Sheeler appears most often in the guise of high priest. During his own era, most critics viewed his representations of factories, skyscrapers, and other technologically sophisticated artifacts as testimony to the machine's supposedly benign omnipotence. A few contemporaries, such as the poet William Carlos Williams and the critic Henry McBride, sensed troubling implications in these subjects, however. For example, McBride once wrote about the artist's industrial subjects, 'If Charles Sheeler has been holding the mirror up to nature and if half these things he says are true then he's got me worried.'[7] But this remark was unusual at the time, and interpreters of Sheeler's art have generally continued to characterize him as an unambivalent advocate of industrial culture in America.[8]

If we judge the meaning of Sheeler's art by his own statements, then again, we are led to identify him as a high priest of the machine age. He expressed fascination with the artifacts of advanced industrial production, astonishment at the accomplishments of industrialists like Henry Ford, and as we

have seen, he identified the machine as the new religion of the twentieth century. But should we limit our investigation into the meaning of a body of work solely to what the artist, or the critics, or other art historians, have said about it? Such a method reduces interpretive possibilities too severely, I believe. Artists and those who study them, like all other human beings, have complicated reasons (often not fully or even partially understood) for saying one thing when they feel something quite different. Ideological factors, or the censoring mechanisms of the conscious mind, often mask unconscious intentions or ambivalences that are not easily recognized or expressed in words.

What artists say about their work *is* extremely significant, however, as is the history of art's critical reception. My approach will consider Sheeler's statements and earlier critical evaluations, as well as the cultural and social context to which the artist belonged. This evidence informs my understanding of the works, but I also fundamentally rely on a careful, empathetic reading of the paintings and photographs as a method to determine meaning. Such an approach uncovers previously unexplored aspects in the works – tensions and conflicts characteristic of the artist's own complex desires and fears and also of the era's larger ideological contradictions.

Although Sheeler's statements voice for the most part a confident stance towards the machine age, his works indicate that he felt personally endangered. The images reveal that the price of American industry's 'efficient' organization of production is an oppressive, dehumanized technocracy – one that has little room for personal and creative autonomy. By considering together statements, contexts, and works, we begin to see the heretical side of Sheeler's machine-age art.

The Machine Age in America

What precisely was the machine age in America? When did it begin? How did the artists of Sheeler's generation help define it for the contemporary audience?

These questions demand our attention at the outset of this study, but although it is possible to state them concisely, they elude easy explanation. For one thing, it is never possible to characterize exhaustively a historical epoch, nor to pinpoint precisely its beginning and end. As Siegfried Giedion wrote, 'History bares itself only in facets, which fluctuate with the vantage point of the observer.'[9] The interpreter's subjectivity inevitably colours a reading of the historical evidence which, in itself, is complex, often contradictory, and unavoidably incomplete. Nevertheless, the visual and verbal documents of this era suggest a historically bounded set of interrelated beliefs, longings, and fears. In my research, several patterns emerged and intertwined, forming a vivid picture of an age – in some ways very different from, in others, quite like, our own. What particularly struck me was a sense of the machine age's mythical veneer – as fascinating and distinctive as the concrete economic and social bases of the period.

The characteristics of the machine age consisted not only of the technologically sophisticated phenomena that emerged – such as sixty-storey skyscrapers, modern factories, and mass-produced consumer products – but also of a wide range of attitudes towards these things. It was a time when presidents, industrialists, artists and intellectuals extravagantly idealized the machine for its supposed potential to create a perfectly functioning, efficient, and just society. Calvin Coolidge uttered a statement that exemplifies this machine idolatry: 'The man who builds a factory builds a temple. The man who works there worships there.'[10]

Coolidge's sentiments, indicating a self-satisfied, grandiose allegiance to the American industrial system, represented the majority view, but attitudes towards the machine's impact on society were never homogeneous. The national exploitation of technology and industry also raised pointed criticism. For

example, in 1921, the critic Paul Rosenfeld published an essay in *The Dial* that caustically satirized the popular quasi-religious attitude towards industry: 'The Book of Genesis was rewritten, and made to declare, "In the beginning, God created the heavens, the earth, and industrial competition."'[11] But a fascination with American industry did dominate the era, both at home and abroad – even in socialist countries.[12]

To many, Frederick Winslow Taylor's principles of 'scientific management' were an especially important model for the organization of modern society.[13] Scientific management was a system of industrial reform instituted by Taylor, an American engineer, in the early 1880s, and further developed by his followers Frank and Lillian Gilbreth. The aim of this reformist programme was to increase efficiency and productivity in all aspects of industry, but especially with regard to the work of factory labourers. Time and motion studies were conducted in order to assess how to increase worker efficiency in the factory setting. This often involved forcing labourers to eliminate 'unnecessary' movements and to work under ever-increasing time pressure. Under Taylor's methods, the activities of workers became more restricted, systematic and machine-like as they performed their tasks.

The machine age perhaps had its most extreme impact on factory workers. Wages rose as a by-product of increased industrial productivity but at the cost of almost intolerable working conditions. Manufacturers no longer sought craft expertise and individual initiative in their employees, but instead, they hired those who were malleable and could tolerate long hours of performing repetitive, mindless activities.[14] In Rosenfeld's view, industry's mechanization of labour 'had reduced the greater part of the community to doing work fit for morons'.[15]

In fact, Taylor once wrote that an 'intelligent gorilla' could be trained to become more efficient than a human worker in heavy industry. In an essay written during the 1930s, Antonio Gramsci, the Italian social theorist, analysed Taylor's callous remark as characteristic of the American managerial attitude towards labour that crystallized during this period:

Taylor is in fact expressing with brutal cynicism the purpose of American society – developing in the worker to the highest degree automatic and mechanical attitudes, break-

ing up the old psycho-physical nexus of qualified pro-
fessional work, which demands a certain active participation
of intelligence, fantasy and initiative on the part of the
worker, and reducing productive operations exclusively to
the mechanical, physical aspect.[16]

Central to the development of the machine age in America
was this new, ideologically and economically expedient con-
cept of human beings as mechanical components in a nexus
of dehumanized production.

This concept was allied with dramatic changes in the work-
place, which instituted standardization, mechanization, and
enormously increased output as the norm. The automobile
industry provides the most striking example of these develop-
ments; its innovative production techniques also became an
important model for most other large manufacturing concerns
of the time. The Ford Motor Company led the way, becoming
synonymous with the very concept of mass production.[17] In
1900, the annual output of automobiles in America was only
four thousand, but that number grew to 4,080,000 in 1923,
and Ford was responsible for 57 per cent of the volume.[18]

During this period, Henry Ford himself had a cult following;
his manufacturing principles were dubbed 'Fordism' or 'Ford-
ismus', and his managerial innovations even seemed politi-
cally enlightened to some progressive intellectuals in Europe.
Figures like Le Corbusier felt that Ford had developed a kind
of benign 'primitive socialism'.[19] But although Ford once had
ambitions to be President of the United States, he claimed
that 'political boundaries and political opinions don't really
make much difference'.[20]

The working atmosphere in Ford's factories was in actuality
far from a socialist utopia. From 1910 to 1914, Ford introduced
a variety of innovations in automobile production at the High-
land Park plant in Detroit: the principles of scientific manage-
ment, standardized and interchangeable parts, and the
moving assembly line. Within this short period, the time
required to assemble a Model T was reduced tremendously,
production increased phenomenally, and profits soared.[21]
Ford's share of the market was only 20 per cent in 1911; by
1913, it had jumped to 48 per cent.[22] But intense worker
dissatisfaction accompanied this increased productivity be-
cause the new methods destroyed traditional shop practices

in which autonomy, inventiveness and skill were valued; now working conditions had become extraordinarily dehumanizing.[23] The automated assembly line moved past the workers at a steadily increasing rate, placing ever greater stress on them to complete their tasks. One ten-year veteran at the Ford Motor Company reported that 'workers cease to be human beings as soon as they enter the gates of the shop. They become automatons and cease to think. . . . Many healthy workers have gone to work for Ford and have come out human wrecks.'[24] Without the protection of a union, workers protested most effectively by simply quitting their jobs, and by the end of 1913, the labour turnover was an astounding 370 per cent at the Highland plant.[25]

In 1914, Ford ingeniously countered this labour unrest by instituting the 'Five Dollar Day' – a paternalistic, profit-sharing plan for his workers. The going daily rate for unskilled factory workers was then only $2.50. Under the new plan, the employee's compensation doubled – but only if he maintained a code of behaviour imposed on him by Ford's Sociological Department, which involved unprecedented managerial monitoring of a worker's personal thriftiness, sobriety and morality as well as tardiness, absenteeism and productivity on the job. This new system – typical of progressive beliefs about industry's responsibility towards improving social conditions – exerted an incredible amount of intrusive control over Ford workers' personal lives.

As Gramsci realized, Ford's aim was to retool men as well as machines, to formulate a new kind of worker geared to the innovations in industrial technology.[26] Dissatisfaction among employees continued, but because of the powerful financial incentives offered by the 'Five Dollar Day', labour turnover diminished by 90 per cent.[27] This solved – at least in the short run – Ford's labour problems. And by staying on, the workers also became more solidly intertwined in the industrial system, supplying a stable labour force while also spending their increased wages on mass-produced goods, thereby fuelling the cycle of increased production and consumption.

During this era, large-scale industries like the Ford Motor Company needed to stimulate consumption because their ability to manufacture goods now far outstripped pre-existing demand. In the long run, strategies like Ford's 'Five Dollar Day' failed to regulate morals but labour's increased buying

power brought in ever greater profits for the company while effectively pacifying demands for a humane work environment.[28] Peter Ling has concluded that 'the consumer culture of which the automobile was such a conspicuous feature in the 1920s served both to facilitate the smooth acceleration of capital accumulation . . . and to inhibit labour's desire to challenge the hegemony of capital'.[29] As one labour organizer of the time recognized, 'As long as men have enough money to buy a second-hand Ford and tires and gasoline, they'll be out on the road and paying no attention to union meetings.'[30]

A few commentators of the period criticized Ford's philosophy and practices. In 1923, Matthew Josephson ironically declaimed:

> Mr Ford, ladies and gentlemen, is not a human creature. He is a principle, or better, a relentless process. Away with waste and competitive capitalism. Our bread, butter, tables, chairs, beds, houses, and also our homebrew shall be made in Ford factories. There shall be one great Power-house for the entire land, and ultimately a greater one for the whole world.[31]

But during the 1920s, those who idealized Ford's remarkable accomplishments in the industrial sphere far outnumbered his detractors. A poll in *Collier's* magazine placed Ford first in the readers' preferences for a presidential candidate, well ahead of the incumbent, Warren G. Harding. And in 1922, Ford even received the endorsement of the American Federation of Labor in his efforts to win a contract for a hydroelectric energy project.[32] His manipulative treatment of workers apparently did little to diminish the widespread view – in both vanguard and popular circles – that Ford's management of the industrial system was the model for an ideal society in the future.

The history of the Ford Motor Company strikingly illustrates managerial practices of the time and the developments that caused industrial production in America to double between 1919 and 1929; and because wages also rose, the average citizen received much more disposable income. A wealthier American public – newly initiated into the phenomenon of credit buying – voraciously consumed unprecedented quantities of mass-produced goods. The number of telephones

increased from 1,355,000 in 1900 to 20,200,000 in 1930. The consumption of canned foods doubled between 1914 and 1929.[33] Convenience appliances proliferated because of the increasing availability of electricity. Electrification of American homes rose from 24 per cent in 1917 to almost 90 per cent in 1940. This paved the way for an influx of radios, vacuum cleaners, washing machines, and toasters, even into households with only moderate incomes. The increased consumption of electric refrigerators provides the most dramatic example of this burgeoning consumerism. Introduced in 1916, refrigerators were owned by 5,000 Americans in 1921. That number rose to 890,000 by 1929. By 1934, there were seven million in America.[34]

These social and economic developments suggest a chronology for the machine age in America, beginning in the early 1910s and reaching its peak during the boom years of the 1920s. As a visual analogue to such developments, paintings and photographs of machine-age subjects emerged in the early twentieth century and continued to proliferate throughout the 1930s. The Depression marks a turning point in the era, however. Industry's collapse after the stock market crash severely curtailed American consumers' disposable income, and it also called into question the entire system on which the economy of the United States was based. Charlie Chaplin's immensely popular film *Modern Times*, for example, exemplifies this changed attitude towards managerial practices in American industry. Released in 1936, the movie includes an unforgettable sequence in which speed-ups on an assembly line cause a harried worker to go insane. Yet even during the Depression years, marketing strategies tailored to hard times still traded on the glamour of the machine age and were often successful in generating enormous sales, as in the example of refrigerators cited above.

In the 1940s, the ideological underpinnings of the era finally came undone. The sophisticated weapons used during the Second World War, especially the devastating atom bomb, effectively diminished the popular idealization of advanced technology as a benign force for social regeneration. Not coincidentally, machine iconography became less prevalent in the post-war era as abstract pictorial idioms began to dominate the art scene in America.[35]

Nevertheless, the concept of dehumanized technological

production has continued to transform life in the United States during the post-industrial era, even though the public largely remains cynical or fearful of its impact. In the highly bureaucratic corporate sphere, huge multinational companies identified by cypher-like acronyms – IBM, for example – have risen to prominence over the older fiefdoms associated with individual entrepreneurs such as Ford and Woolworth. No longer 'presidents', heads of companies now bear the depersonalized title of 'CEO'. The machine-age concept of the individual has been transmuted and diffused; now – along with factory labour – individual white-collar workers, consumers and even corporate officers disappear into an anonymous network of economic activity.

In this respect, the legacy of the machine age remains with us today; there was an important prehistory to the era as well. Between 1840 and 1880, American manufacturing spread from small-scale, rural locations to large, multifaceted urban complexes. From the 1880s to the early twentieth century, most large cities spawned an 'industrial zone' on their outskirts. Although, for the most part, painters of this era ignored these regions, popular magazines and trade journals proclaimed their aesthetic character.[36] Regarding the steel-producing district in Pittsburgh, one commentator in 1901 described 'the tremendous, almost inconceivable magnitude of this giant industrial exposition, where above all other places a realization of the majesty of manual labor burns itself into the brain.'[37] Along with the tall office building and the suspension bridge, these industrial regions fundamentally transformed the American cityscape and attracted much attention in mass-circulation magazines and trade publications.

Commentators in these journals often pointed to developments in commerce and industry with nationalistic pride, but genteel artists and intellectuals in both Europe and America were generally horrified by skyscrapers, factories, and the commercial values that gave rise to such phenomena.[38] Henry Adams described this scorn in his autobiographical writings of 1907: 'From the old-world point of view, the American had no mind; he had an economic thinking-machine which could work only on a fixed line.'[39] Self-criticism abounded in the United States as well. The critic Charles Caffin declared in 1903:

. . . Our present American civilization . . . makes haste to pollute the stream and to foul its banks with the reek of commercialism, and exacts from the artist conformity to its own standards or threatens him with severe neglect. America declares itself the greatest nation on earth, and yet, in matters artistic, I wonder sometimes if it be not the greatest grinder-down of the individual to mediocrity.[40]

Turn-of-the-century developments in industry and commerce generally appalled the genteel sensibilities of the era.

Among a few American printmakers, painters and photographers, however, a new curiosity about the industrial zone emerged at the start of the century. Joseph Pennell, Childe Hassam, John Twachtman, and Alfred Stieglitz began turning their attention to factories, bridges and skyscrapers, virtually unprecedented subjects in the so-called fine arts. In 1909, the impressionist Birge Harrison wrote an early, if rather bland, defence for such motifs: 'There is certainly a strange picturesqueness in some of our modern steel mills, with their cyclopean forces at work against backgrounds of whirling steam and glowing furnace. Even our sky-scrapers have an unusual beauty of their own, and the sky-line of lower New York is far from being ugly or uninteresting.'[41]

Ash Can School artists, in their rebellion against genteel values, were particularly interested in the changing New York cityscape as a symbol of modernity. For example, John Sloan's *Dust Storm, Fifth Avenue* (illus. 4), depicts Madison Square with the newly completed, twenty-one-storey Flatiron Building looming in the background. Erected in 1902, the lofty Flatiron immediately dominated the much smaller buildings around Madison Square and quickly appealed to artists as a symbol of America's engineering expertise and new cultural vitality.[42] Using his characteristically spontaneous, painterly style, Sloan made the thin, aspiring skyscraper central to his composition. But equally important are the floundering individuals in the foreground, scurrying with exaggerated expressions of panic on their faces as they run for shelter from the tempestuous storm. The city, while modern and dynamic, remains profoundly human in the artist's view.

Like Sloan, the Flatiron Building also captured Stieglitz's attention (illus. 5). It stood not far from the photographer's gallery at 291 Fifth Avenue.[43] Unimpressed with the building

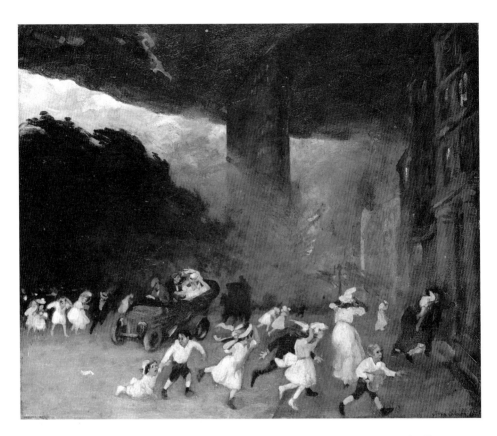

while it was being erected, Stieglitz suddenly saw the structure with new eyes on a snowy day. He described his impression of it at this moment: 'It appeared to be moving toward me like the bow of a monster ocean steamer – a picture of a new America still in the making.'[44] But Stieglitz's image does not present the building as a hard, mechanical thing. Instead, the snowstorm provides a thick, hazy atmosphere that effaces the potentially harsh juxtapositions of engineering and nature. The tree in the foreground seems to embrace the building; both grow out of the same earth. The benches in the park give the skyscraper a human context, as does a cloaked pedestrian silhouetted against the skyscraper's base. In addition, Stieglitz's printing techniques using platinum paper create soft, melting forms that further unify the building with its natural and human environment.

These artists' subjects, as Wanda Corn has noted, 'provide pictorial witness to the growing preoccupation with New York's modernity and uniqueness'.[45] But like Sloan and Stieg-

4 John Sloan, *Dust Storm, Fifth Avenue*, oil, 1906

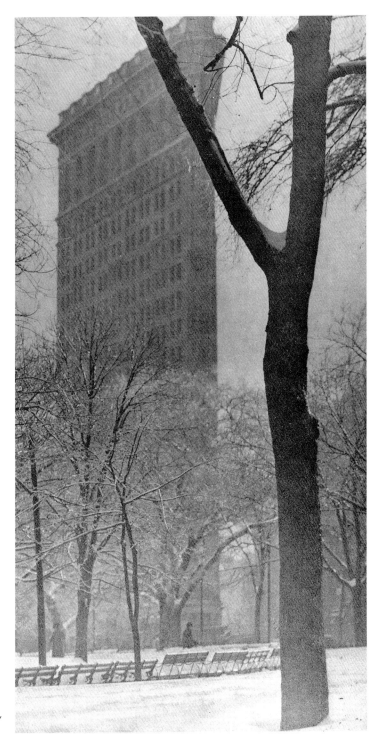

5 Alfred Stieglitz,
The Flatiron Building,
photograph, 1903

litz, most American artists in the first decade of the twentieth century approached the city from an aesthetic point of view that made the subject seem natural and picturesque; they softened and mellowed the jagged, crisp outlines of tall buildings and factories. The hard, aggressive forms of American engineering dematerialized in the midst of thick painterly impastos, velvety etched surfaces and soft-focus photographic images.

In Corn's view, these turn-of-the-century artists had their feet in two worlds simultaneously. Their subject matter was up-to-date, but their stylistic presentations, which involved well-established painterly or picturesque conventions, inadequately conveyed the radical newness of urban and industrial America. In response, Donald Kuspit has written, 'This use of a traditional manner to treat an untraditional subject was as much a defense – or offense – against the subject as a sign of the artist's inadequacy to it. It suggests a resentment of modernity, a reluctance to accept its inevitability.'[46] According to Kuspit, Stieglitz used urban subjects as much to confess estrangement as to express allegiance to modernity.[47] The photographer's own words suggest as much: the Flatiron Building was not only 'a picture of new America' but 'a monster' as well.

Stieglitz's image does not induce terror, however. The skyscraper appears as a mysterious but not unfriendly entity. On an immediate, visceral level, the photograph seems to reconcile the machine with humanity, to assert the power of the human imagination over technological intrusions in a way that makes them at once artful and integrated into a larger context. Indeed, Stieglitz and others in his circle felt that one of art's highest callings was to counteract the fragmenting, dehumanizing effects of the machine.

Picturing the modern cityscape as a natural organism was therefore the American artist's first strategy for coping with the radical newness of the machine age. Early in the 1910s, painters such as John Marin departed from this naturalized view of urban forms and developed a Cubist and Futurist-inspired aesthetic approach that synthesized multiple vantage points and suggested a simultaneity of heterogeneous sights and sensations.[48] Marin's *Movement, Fifth Avenue* (illus. 6) presents modern urban experience as intensely stimulating, but also as disconnected, fragmented and disorienting. In his

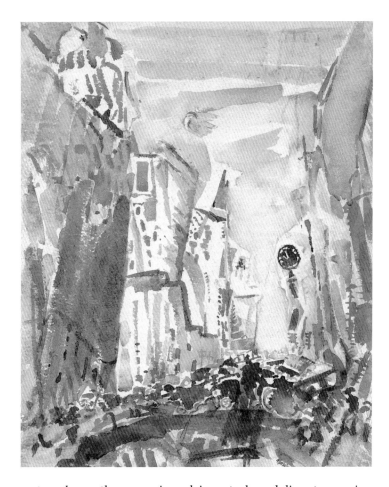

6 John Marin,
*Movement, Fifth
Avenue,*
watercolour, 1912

watercolour, the raw, impulsive strokes delineate soaring buildings that quake and sway with unbridled energy while swarms of cars and pedestrians mingle violently below. This kind of presentation confronts the novelty of modern urban forms more straightforwardly than did Sloan and Stieglitz. Marin plays down the natural and the human aspects of the city: people are swallowed up in the manic, modernist energy of the scene. And yet, Marin still conceived of these buildings in human terms – as objective correlatives to his own experience. He explained that 'if these buildings move me they too must have life. Thus the whole city is alive; buildings, people, all are alive; and the more they move me the more I feel them to be alive.'[49]

Marin's urban vitalism was violent and competitive – in his own words, 'warring, pushing, pulling'.[50] Such language,

as well as the work itself, provides an apt analogue to the aggressive commercial values underlying New York's unfettered building activity in the early years of the century. Unlike the genteel artists and critics of the previous generation, this was a spirit with which Marin could identify. His work represented a new alliance between machine culture and modernist visual representation, but one that still glorified individualistic, emotive self-expression.

During the 1910s, visiting European artists were also fascinated by the monuments of American engineering. Albert Gleizes spent part of the war years in New York, and the city overwhelmed him. He told a reporter: 'The sky-scrapers are works of art. They are creations in iron and stone which equal the most admired Old-World creations. And the great bridges here – they are as admirable as the most celebrated cathedrals.'[51] By the end of the First World War, a European point of view had emerged that no longer regarded America as without aesthetic merit. Throughout the 1920s, there persisted a European 'conceptualization of America as pattern for a new, completely modern style of personal and social life free of historical baggage. . . .'[52] These positive European assessments of the culture also stimulated the ongoing native reappraisal of the American scene. Increasingly, something good could be said about a country dominated by the values of industry, commerce and engineering.

Despite their vocal appreciation of America's machine-age monuments, transplanted European artists also played an important role in creating a deadpan, satirical, dehumanized presentation of the country's mechanized environment. The most important of these temporary expatriates were Marcel Duchamp and Francis Picabia, who viewed the aesthetic traditions of their native France with vociferous irony and disdain. Because of their mischievous iconoclasm and their penchant for irony, they were predisposed to investigate America's machine-age culture as an alternative to the refined artistic traditions of Europe.

Picabia first arrived in New York in 1913 to attend the opening of the Armory Show – the grand international display of over 1600 paintings and sculptures that introduced European modernism to an unprepared American public.[53] To news-hungry reporters, he boldly declared: 'France is almost outplayed. It is in America that I believe that the theories of

The New Art will hold most tenaciously.'[54] He also lectured native artists about the aesthetic modernity of their urban environment: 'Your New York is the cubist, the futurist city. It expresses in its architecture, its life, its spirit, the modern thought. You have passed through all the old schools, and are futurists in word and deed and thought. . . . I see much, much more, perhaps, than you who are used to it see.'[55]

Picabia returned to New York in 1915, again claiming enthusiastically that 'America is destined to become the high court of the "modernists"'.[56] After four months in the country, he declared: 'Since machinery is the soul of the modern world, and since the genius of machinery attains its highest expression in America, why is it not reasonable to believe that in America the art of the future will flower most brilliantly?'[57] Duchamp, who also arrived in 1915, agreed that the 'American character contains the elements of an extraordinary art' and especially admired the 'cold and scientific' nature of American life.[58] Both artists became important members of avant-garde circles in New York, frequenting Stieglitz's '291' Gallery and the high-spirited salons hosted nightly by Walter and Louise Arensberg.[59]

In their work produced in America, both these expatriates explored, not the city, but the machine itself as the quintessentially modern subject. The two Dada iconoclasts created images that represented a fundamental rethinking of the human place in the machine-dominated world. Although both had previously painted in a Cubist-inspired style, Duchamp developed a crisply linear, diagrammatic idiom, as in his *Chocolate Grinder* series (illus. 7) of 1913–14, which was an important prelude to his most famous work done in America, *The Bride Stripped Bare by Her Bachelors, Even* (Philadelphia Museum of Art). Influenced by utilitarian modes of representation found in advertisements and trade catalogues, Duchamp presented single or interrelated machines isolated on a blank ground. The invocation of common, mechanical objects rendered in a style reminiscent of banal, commercial illustrations slyly undercuts the traditional humanist view of artistic practice as an elevated, original, autonomous endeavour. Duchamp's ready-made sculptures – common, mass-produced objects from hardware stores and plumbing supply shops – challenged these notions even more audaciously.

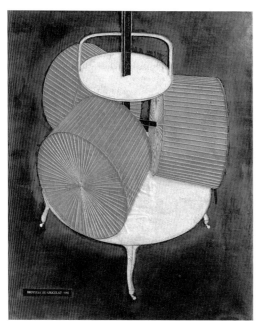

7 Marcel Duchamp,
*Chocolate Grinder,
No. 2*, oil, pencil
and thread,
1914

In 1915, Picabia followed Duchamp in renouncing Cubism's complex faceting of forms and developed a similar Dadaist mode of representation. Picabia's work of this time gave concrete form to his perception that in America 'the machine has become more than a mere adjunct of human life. It is really a part of human life – perhaps the very soul.'[60] His painting, *Universal Prostitution* (illus. 3), depicts male and female mechanomorphs engaged in a bizarre kind of sexual activity akin to the operation of a piston engine. The vertical male machine, somewhat resembling a telephone, automatically spits out disjointed messages – 'convier . . . ignorer . . . corps humain' – while connected by electric wires to the kneeling female machine identified as 'sexe feminin ideologique'. Offending conventional romantic notions of sexual union, these flimsy, hybrid creatures mechanically pursue unsanctified instinctual urges in a soulless, dehumanized way. They suggest that the machine has invaded the most intimate areas of life; individuals prostitute themselves to it in their unthinking embrace of it. Picabia's mechanomorphs also brutally enact a humiliating relationship of male domination and female submission. Such implications challenge the positive qualities associated with the machine by utopian-minded believers in industrial progress. At the same time,

they concretize the prevalent fears about the mechanization of contemporary life.

Despite the obvious cynicism and satire in their works, Picabia and Duchamp's thematic treatments of the machine are curiously difficult to decipher within the context of their time. These darkly nihilistic mechanomorphs are especially hard to reconcile with the two artists' enthusiastic statements about America as the land of a new machine-age art – although Duchamp's famous remark, 'the only works of art America has given are her plumbing and her bridges',[61] indicates a sneering disregard for native painting and sculpture compared to the country's technological achievements.

Yet in spite of the obvious satire in these Dadaist works, they inspired commentary that seemed confident in humankind's ability to control the machine. In 1915, Paul Haviland referred to Picabia's mechanomorphs in the magazine *291*:

> Man made the machine in his own image. She has limbs which act; lungs which breathe; a heart which beats; a nervous system through which runs electricity. The phonograph is the image of his voice; the camera the image of his eye. The machine is his 'daughter born without a mother'. . . . Man gave her every qualification except thought. She submits to his will but he must direct her activities. . . . Through their mating they complete one another. She brings forward according to his conceptions.[62]

But this seemingly confident passage perhaps masks a significant degree of nervousness. Haviland's rhetorical strategy of feminizing the machine strains to reassure readers that the power relationship of man over machine is a 'natural' one.

Several American artists came to share Duchamp and Picabia's interest in machine forms, but for the most part, their attitudes towards these subjects appear even more elusive and oblique. Among the first American painters to develop machine-inspired imagery was Morton Schamberg, Sheeler's closest colleague from the Pennsylvania Academy and a fellow habitué of '291' and the Arensberg salon. In these circles, Schamberg encountered Picabia and Duchamp, and the French artists' works undoubtedly reinforced Schamberg's already well-developed interest in machine culture. In 1916, he produced eight oil paintings depicting isolated machines, such as the elegant *Mechanical Abstraction* (illus. 8).

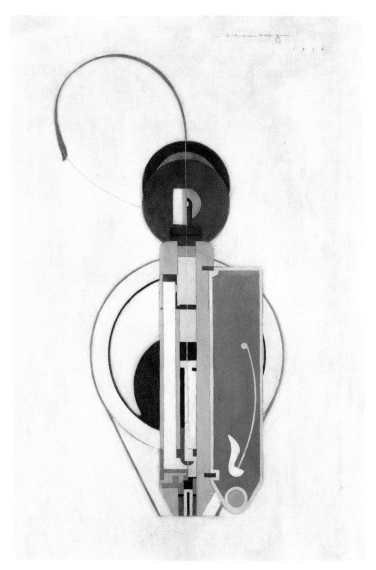

In its diagrammatic form isolated from any practical context,
Schamberg's machine relates to the style of Duchamp and
Picabia's mechanomorphs. Like the French artists, he studied
trade catalogues of machinery obtained from his brother-in-
law, who was a manufacturer of ladies' cotton stockings.[63]
Thinly painted and exquisitely precise, *Mechanical Abstraction*
is in fact a geometrically simplified rendering of a sewing
machine, perhaps a representation of one used in Schamberg's
brother-in-law's business.[64] Unlike Duchamp and Picabia's

work, however, Schamberg's paintings of machines are not mechanomorphic and exhibit no blatant irony.[65] In fact, his paintings present beautiful, precise, mechanical forms with few overtly human associations.[66] Such images seem to confirm Albert Gleizes's observation that American artists had taken a 'leap head first into the impersonal'.[67]

Despite the influence of Picabia and Duchamp, the Americans adopted the machine in a less obviously critical way. This relates, I believe, to the specifically nationalistic agenda of native modernists at the time, which encouraged a positive identification with industry and technology. The Armory Show breathtakingly displayed European aesthetic sophistication, even though works by Picasso, Matisse, Duchamp and Picabia generally confused, repulsed or merely amused the uninitiated public and conservative artists.[68] The American works in the exhibition, although more numerous than the European paintings and sculptures, looked timid and provincial in comparison – at least to those observers who were sympathetic to modernism. The daringly innovative French paintings especially entranced and intimidated the American vanguard. As Sheeler wrote about a Matisse painting he saw in the exhibition: 'We had never thought a picture could look like that – but there it was to prove it. Pictures like this offered . . . evidence that a picture could be as arbitrarily conceived as the artist wished.'[69]

The Armory Show stimulated an intense period of aesthetic experimentation inspired primarily by Cubism. Its model freed American artists from a 'servile imitation of nature', the prominent art critic Forbes Watson claimed in 1915. Watson felt, however, that native painters were now in danger of a 'servile imitation of Paris'.[70] The literary critic Randolph Bourne perceived the same subservience in American letters: 'Our cultural humility before the civilizations of Europe . . . is the chief obstacle which prevents us from producing any true indigenous culture of our own.' He recommended instead 'the cultivation of a new American nationalism'.[71] Sharing this nativist sentiment, many American modernists rebelled against the pre-eminent regard for foreign art. In 1916, the Forum Exhibition at the Anderson Galleries in New York was organized in order 'to turn public attention for the moment from European art and concentrate it on the excellent work being done in America'[72] A widespread feeling arose

that the country had to develop its own modernism, something separate from – but equal to – that of Europe.

In this context, Picabia, Duchamp and Gleizes's statements about America as the land of a new art gave solace and hope for the future. They claimed that America had already created the most up-to-date urban and industrial environment in the world. Its art could be the most progressive and least burdened by national traditions because the country lacked a cultivated past. Native artists listened attentively to part of this message. They embraced the idea of creating a modernist identity based on identification with the machine, but remained nationalistic in their agenda.[73] It was important to affirm machine-age subjects, not only as a means of legitimizing one's status as a modernist, but also as a strategy of creating a viable, unique and specifically national artistic identity as well.

America's participation in the First World War heightened the need to separate from Europe, but it also temporarily interfered with these developments. Journals like *The Seven Arts*, which had vigorously proselytized for a new cultural nationalism, folded. As a result of wartime economic disruption, Stieglitz's '291' Gallery closed in 1917; some artists were drafted or, like Sheeler, feared induction into the army.[74]

With peace and economic recovery, however, American modernists continued to define themselves through exploiting the image of the machine. By the early 1920s they had established the range of their machine-age iconography and three dominant groups of motifs had emerged. One group consisted of depictions of individual machines, like Morton Schamberg's *Mechanical Abstraction* (illus. 8), or mass-produced commodities, such as Stuart Davis's *Lucky Strike* (Museum of Modern Art, New York). Images of urban America comprised a second group, especially views of New York City, such as Stefan Hirsch's *New York, Lower Manhattan* (illus. 15). The last group included industrial buildings, such as Charles Demuth's *End of the Parade: Coatesville, Pa.* (illus. 30).

American artists focused predominantly on urban architecture, factories or machines themselves – all products of innovative American expertise in engineering or manufacturing. In their imagery, we see few people at work or enjoying the fruits of advanced technology. The strategy of nationalistic identification with the machine continued throughout the

1920s and 1930s, but few images matched the serene composure of Schamberg's *Mechanical Abstraction*. Some painters, such as John Marin in *Lower Manhattan*, illus. 24), continued to infuse their subjects with anthropomorphic energy. More typically, artists depicted a machine-age world where dehumanization, standardization and anonymity prevailed.

Eventually, Sheeler's work incorporated all the various motifs developed to interpret the machine age in America. But Sheeler embraced machine iconography only gradually and methodically. He introduced skyscrapers into his work in 1920, with a film and photographs depicting lower Manhattan (illus. 17, 20, 21, 23) and paintings and drawings of the same subjects, such as *Skyscrapers* (illus. 32) and *Church Street El* (illus. 33). He represented a machine in his witty *Self-Portrait* (illus. 67) of 1923; others emerged in paintings of the early 1930s, such as *View of New York* (illus. 63) and *Home Sweet Home* (illus. 64). His engagement with industry began in 1927 when he photographed the Ford automobile factory (illus. 41–45). In the early 1930s, his reflections on the machine age crystallized in powerful paintings such as *Classic Landscape* (illus. 37).

The artist's formative years provided the backdrop for the development of these subjects in the 1920s. In the next section, we will examine Sheeler's early career in order to understand the context for his evolution into one of the major iconographers of the machine age in America.

Sheeler's Early Career

Born in 1883, Sheeler came from a middle-class family in Philadelphia. His father worked for a steamship line; his mother was an Irish immigrant.[75] Unusually supportive, both of his parents encouraged his early aspiration to be a painter. But the head of the Pennsylvania Academy of the Fine Arts, one of the leading art schools in America, dissuaded Sheeler from enrolling in that institution. For three years from 1900 to 1903, he studied instead at the School of Industrial Art in Philadelphia – a seemingly appropriate training for a future iconographer of the machine age. In actuality Sheeler detested the routinized aspects of his training at that school and eventually achieved admission to the Pennsylvania Academy. From 1903 to 1906, he attended courses at the Academy, excelling in the painterly style of his flamboyant teacher, William Merritt Chase. Chase's spontaneous, fluid technique derived from a study of late Impressionism and the work of Diego Velázquez and Frans Hals.

At the Pennsylvania Academy, Sheeler met Morton Schamberg. The two became inseparable friends, eventually sharing studios in Philadelphia and Doylestown, Pennsylvania. A trip to Paris with Schamberg in 1909, where Sheeler saw the work of Cézanne, Matisse, Picasso, and Braque, convinced him of the inadequacy of his training at the Pennsylvania Academy. 'Returning to my studio meant discontent and an unwillingness to resume where I had left off before that voyage of such great portent. An indelible line had been drawn between the past and the future . . .', he later wrote.[76] On returning to the United States, Sheeler began a decade-long struggle to develop a mode of painting congruent with vanguard art in Europe.

By 1913, Sheeler had achieved a modest reputation in progressive art circles, and he was invited to submit four still lifes and two landscapes to the Armory Show. In such works as *Dahlias and Asters* (illus. 31), Sheeler attempted to render simple still-life motifs inspired by Cézanne's experiments with space and volume; simultaneously he adopted a palette influ-

enced by the Fauvists. Sheeler carefully studied the European works at the Armory Show, and their impact on his art was immediate, further propelling him towards abstraction.[77] He often visited New York during this period to view the latest vanguard developments at Stieglitz's '291' and other progressive galleries. He exhibited with his fellow modernists and frequented the Arensberg salon, where he first encountered Picabia and Duchamp.

During the 1910s, Sheeler and Schamberg rented an eighteenth-century farmhouse as a weekend and summer studio in the rural community of Doylestown. There they not only worked in isolation from the hectic activity of the city, but they also acquainted themselves with the rich, vernacular artifactual traditions of the region. Thus began for Sheeler a lifelong fascination with useful objects of American origin. Later his interests would encompass industrial artifacts, but during this period, Sheeler focused solely on examples of early American material culture.[78]

In the first part of the decade, Sheeler's paintings and drawings continued to rely rather unimaginatively on Post-Impressionism and Fauvism; in mid-decade, he adopted the fragmented forms and ambiguous spatial relationships of Cubism, as in the semi-abstract *Landscape, No. 1* (illus. 9). He did not evolve a more independent approach to modernist style, however, until a few years later.

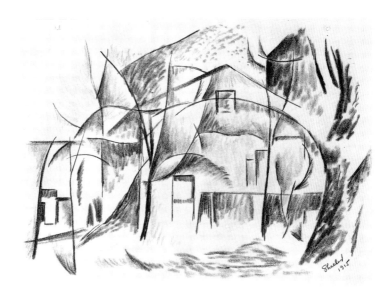

9 *Landscape 1,*
crayon, 1915

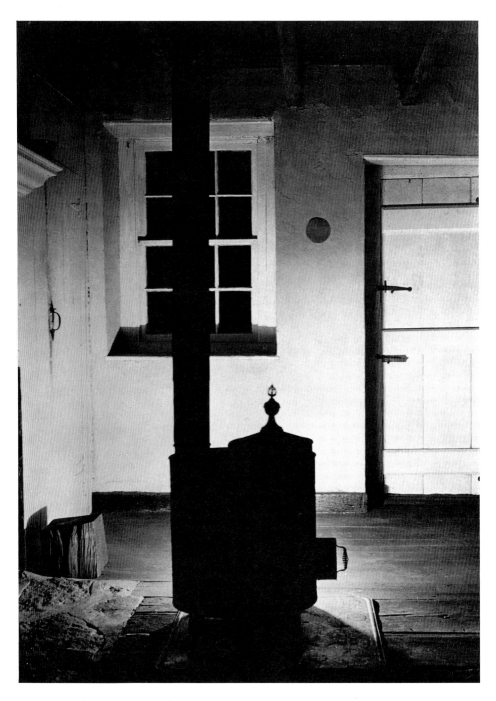

10 *Interior with Stove*, photograph, c. 1917

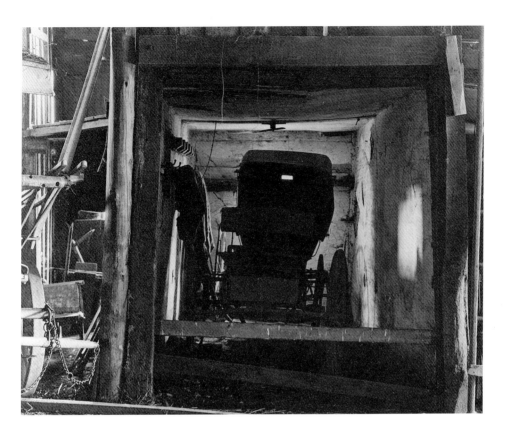

Interestingly, it was photography that helped Sheeler to overcome his over-dependence on foreign precedents in his painting practice. As struggling young artists, both Sheeler and Schamberg took up commercial photography in about 1910 as a way to supplement their incomes.[79] Sheeler photographed newly completed buildings for Philadelphia architects; Schamberg specialized in portraits.

Around 1917, Sheeler began producing experimental as well as commercial photographs. He created striking images of his Bucks County home, such as *Interior with Stove* (illus. 10), which depicts the main room of the eighteenth-century house. Behind the wood-burning stove (an early nineteenth-century addition), a photographer's lamp glows with an eerie light; this reduces the stove to a flat, simplified silhouette. The dramatic, high-contrast lighting makes the composition a formally innovative statement and, at the same time, it accentuates the aged features of the building: the original,

handwrought hardware, exposed ceiling beams and rough, whitewashed plaster.

Interior, Bucks County Barn (illus. 11) is similarly concerned with archaic subject matter and also reveals formal experimentation in the manipulation of the lighting to create bold, assertive shapes. An old buggy sits in a decrepit stall, silhouetted by mysterious backlighting. Depicting the tools and other equipment that fascinated Sheeler, the photograph records the indigenous handcraft traditions of the region. These artifacts – simply designed with function as a primary consideration – represent a design tradition that American commentators since Horatio Greenough have celebrated as a unique national achievement. In fact, Greenough and later functionalists claimed that these kinds of useful objects were aesthetically superior to pretentious, elaborately ornamented designs modelled on high-style European precedents.[80] This American vernacular tradition provided a sense of national origins with which Sheeler identified throughout his career.

Sheeler's most innovative photograph during this period depicts an old barn of the region. *Side of a White Barn* (illus. 12) presents a close-up view of the farm building, whose flat, planar sideboarding seems almost congruent with the pictorial surface itself. The audacious framing of the subject and the emphasis on pictorial flatness in the photographic medium marks the beginning of a new, more independent phase in Sheeler's engagement with modernism. The Bucks County photographs also stimulated more innovative work in other media, such as the elegantly skeletal drawing, *Barn Abstraction* (illus. 13), which is a minimal, almost schematic representation of a local building. Once transformed by modernist principles and practices, Sheeler's crumbling barns and ageing houses became starkly fragmented and strikingly abstract. These stylistic presentations rendered seemingly unlikely subjects relevant to the project of self-definition in both nationalistic and modernist terms.

Indeed, Sheeler's treatment of antiquated, indigenous artifacts signalled his stylistic maturity as a modernist. While European expatriates like Picabia and Duchamp counselled American artists to forget the past and focus on the most up-to-date symbols of urban and industrial modernity, figures like Sheeler enriched their repertoire of subjects by examining their native land more broadly. They depicted rural, preindus-

12 *Side of a White Barn*, photograph, *c.* 1917

13 *Barn Abstraction*, chalk, 1917

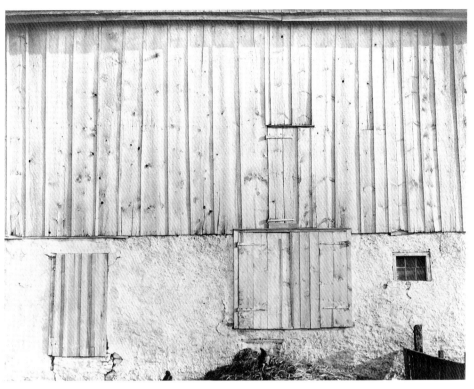

trial artifacts as well as technologically sophisticated factories and skyscrapers.[81] Both kinds of subjects qualified as nationalistic symbols because they seemed linked by an overarching functionalism identified with the American tradition.

In October 1918, Schamberg died tragically from pneumonia, and the bereaved Sheeler moved to New York City shortly afterwards. This had enormous consequences for Sheeler's career. Despite his quiet, introverted nature, he became immediately involved with the vibrant and combative cultural life of the city. His connections with the Stieglitz and Arensberg circles strengthened, and machine-age iconography emerged for the first time in his art.

New York City

From the 1910s to the 1930s, American artists often turned to New York City as a potent machine-age subject. To identify with its striking contemporaneity enhanced an artist's status as a modernist. Painters and photographers repeatedly depicted its skyscrapers, bridges, and elevated railroads. All products of advanced engineering, these phenomena – like factories and consumer products – were the most compelling symbols of America's unique modernity.

Artists often differed dramatically in their estimation of the city, however. To Joseph Stella, the Brooklyn Bridge was the most outstanding monument in New York, and in the immediate post-war years, he painted it as an explosive array of intersecting cables and ascending towers (illus. 14). Cloaked in a mysterious, smoky atmosphere, this dynamic, powerful, and futuristic construction conveys his ebullient view of modern urban forms. The bridge impressed Stella 'as the shrine containing all the efforts of the new civilization of AMERICA – the eloquent meeting point of all forces arising in a superb assertion of their powers, in APOTHEOSIS'. He felt deeply moved by it, 'as if on the threshold of a new religion or in the presence of a new DIVINITY'.[82]

By contrast, downtown Manhattan alienated and alarmed Stefan Hirsch in a way that seems evident in his work, *New York, Lower Manhattan* (illus. 15). Whereas Stella's *Brooklyn Bridge* thrusts the viewer squarely into the urban fabric, Hirsch's painting keeps us at a distance. Seen from outside its precinct across the harbour, the city is filled with anonymous, monolithic buildings. The fact that Hirsch's New York appeared static and forbidding was 'not altogether the accident of abstraction', he explained. It also expressed the artist's 'recoil from the monstrosity that industrial life had become in "megapolitania"'.[83]

Like the artists, the critics of the time responded variously to New York's urban forms. In a 1923 article for *The Arts*, Charles Downing Lay cited the city's tall buildings as evidence of national genius. Interestingly, the article was illus-

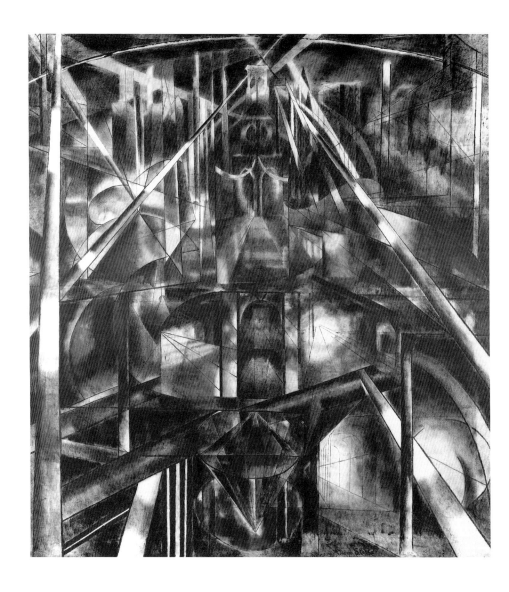

trated with Sheeler's photographs of landmarks such as the Singer Building (illus. 16) and the Shelton Hotel.[84] About such buildings, Lay wrote:

14 Joseph Stella, *Brooklyn Bridge*, oil, 1917–18

New York's architecture is its own in conception and in fulfillment. It is indigenous and can be matched nowhere else in the world. Like all great art it has grown from the conditions of our life and may well be considered by us, as it is by all visitors from foreign parts, as an expression of our composite genius.[85]

During the same years, however, Lewis Mumford sharply criticized the metropolis and the consumerist values associated with it:

We have shirked the problem of trying to live well in a régime that is devoted to the production of T-beams and toothbrushes and TNT. As a result, we have failed to react creatively upon the environment with anything like the inspiration that one might have found in a group of mediaeval peasants building a cathedral. The urban worker escapes the mechanical routine of his daily job only to find an equally mechanical substitute for life and growth and experience in his amusements. . . . The movies, the White Ways, and the Coney Islands, which almost every American city boasts in some form or other, are means of giving jaded and throttled people the sensations of living without

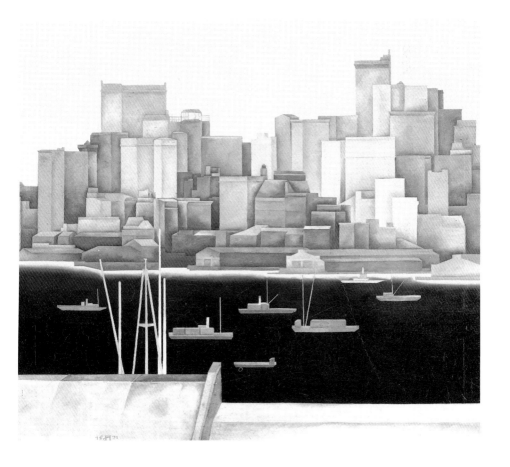

15 Stefan Hirsch, *New York, Lower Manhattan*, oil, 1921

the direct experience of life – a sort of spiritual mastur-
bation. In short, we have had the alternative of humanizing
the industrial city or de-humanizing the population. So far
we have de-humanized the population.[86]

From the time the Woolworth Building was erected in 1913,
skyscrapers – as symbols of Manhattan's commercial energies
– were often regarded in quasi-religious terms, as 'cathedrals
of commerce'. To this cliché, Mumford retorted that the urban
environment was a nightmare unlike anything in the Gothic
age.

What does Sheeler's art tell us about attitudes towards the
city at the time? Does it suggest, as Mumford claimed, that

New York is an impoverished, manipulative, dehumanized place? Or does it present the city as an expression of the composite genius of Americans, in accordance with Lay's beliefs? Sheeler's urban scenes in fact fall somewhere between these two strongly polarized extremes, and in order to understand their complex implications, we must look closely at the artist's professional activities during this period and at the imagery that resulted from his engagement with America's leading metropolis.

By August 1919, Sheeler was living in New York City, newly arrived from Philadelphia. He immediately joined the city's artistic community, where he met creative figures such as the poet William Carlos Williams. In 1921, he married Katharine Shaffer, who was also from Philadelphia. During these years, he continued to support himself as a commercial photographer, specializing in work for private art collectors, galleries, and institutions such as the Whitney Studio Club. He also advanced his reputation as a painter and 'art' photographer through frequent exhibitions of his work. His paintings, drawings, and photographs often appeared in avant-garde and popular magazines of the period.[87]

After Sheeler's move to New York, friendship with photographer Paul Strand evolved into a fruitful collaboration. The two had met about 1917 at Stieglitz's '291' Gallery. In 1920, they made an experimental film together entitled *Manhatta* (illus. 17). One of the first avant-garde films produced in America,[88] the project also heralded Sheeler's debut as an urban iconographer.[89]

Unlike Sheeler, Strand was a native New Yorker. His first teacher, Lewis Hine, had sensitively photographed child labourers and working-class immigrants. Strand began photographing New York in the 1910s, and Hine's socially conscious example inspired a series of penetrating portraits of indigent people in streets and squares. But in Strand's *Wall Street* (illus. 18), city dwellers appear in a different light – as anonymous, tiny presences dwarfed by the massive windows of the banking establishment, Morgan & Company.[90] *Wall Street* diminishes the human subject while accentuating the strikingly abstract patterns of the shadows and architecture, especially the regular alternation of dark, rectangular windows and blank walls. This work, according to Peter Conrad, accuses the city 'of a cruel, immitigable geometry. The hard edges and

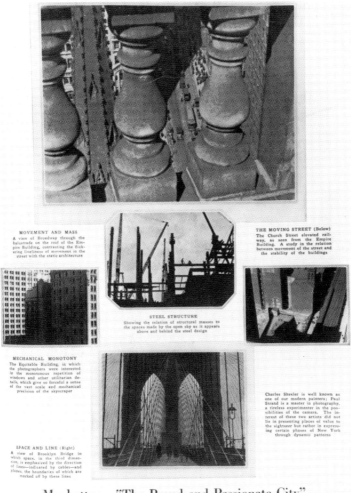

17 Film stills from *Manhatta*, reproduced from '*Manhattan – "The Proud and Passionate City"*', *Vanity Fair* (April 1922)

MOVEMENT AND MASS
A view of Broadway through the balustrade on the roof of the Empire Building, contrasting the flickering liveliness of movement in the street with the static architecture

THE MOVING STREET (Below)
The Church Street elevated railway, as seen from the Empire Building. A study in the relation between movement of the street and the stability of the buildings

STEEL STRUCTURE
Showing the relation of structural masses to the spaces made by the open sky as it appears above and behind the steel design

MECHANICAL MONOTONY
The Equitable Building, in which the photographers were interested in the monotonous repetition of windows and other utilitarian details, which give so forceful a sense of the vast scale and mechanical precision of the skyscraper

Charles Sheeler is well known as one of our modern painters; Paul Strand is a master in photography, a tireless experimenter in the possibilities of the camera. The interest of these two artists did not lie in presenting places of value to the sightseer but rather in expressing certain phases of New York through dynamic patterns

SPACE AND LINE (Right)
A view of Brooklyn Bridge in which space, in the third dimension, is emphasized by the direction of lines—indicated by cables—and planes, the boundaries of which are marked off by these lines

Manhattan—"The Proud and Passionate City"
Two American Artists Interpret the Spirit of Modern New York Photographically in Terms of Line and Mass

acute angles of the Morgan Guaranty Trust Building . . . define a mechanical city which is hostile to human purposes.'[91] Strand himself admitted that the void-like windows were 'rather sinister'.[92]

In placing people within a geometric urban grid, Strand's image resembles some of Stieglitz's New York photographs of the 1910s. For example, Stieglitz's *The Ferryboat* (illus. 19) is similarly concerned with abstract patterns and the dehumanization of the subject. In the crowd of commuters, numerous passengers all wear the same light-coloured straw hats. Because of this, they appear visually analogous to the inanimate

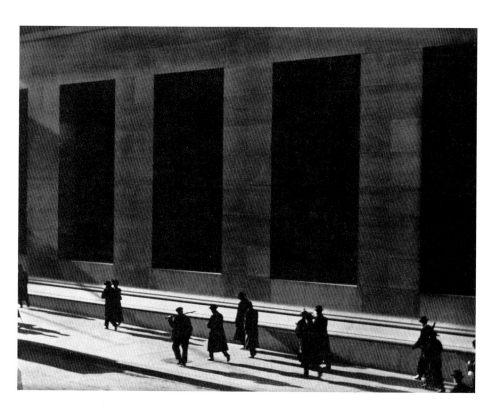

painted posts on the ferry dock, a similarity that is hardly complimentary to the anonymous mass of commuters. On the one hand, both *Wall Street* and *The Ferryboat* seem to glorify the visually arresting modernity of New York; yet on the other, the photographs reveal a disturbing sense of anonymity and conformity in the human life of the metropolis.

Such interpretations of the city overlapped in the work of Stieglitz, Strand, and Sheeler during this period. Stieglitz enthusiastically admired Sheeler's Bucks County photographs in the late 1910s, and for a few years following Schamberg's death, Strand became Sheeler's closest artistic colleague. The idea for *Manhatta* evolved as Sheeler was showing Strand his recently purchased and quite expensive Debrie movie camera. Sheeler suggested that they make a film about New York together, and the collaboration was ideal in many respects. Each photographer brought different areas of expertise to the project: Sheeler had made experimental films previously, while Strand had not; but Strand had greater experience in photographing New York.[93] According to Strand, the seven-

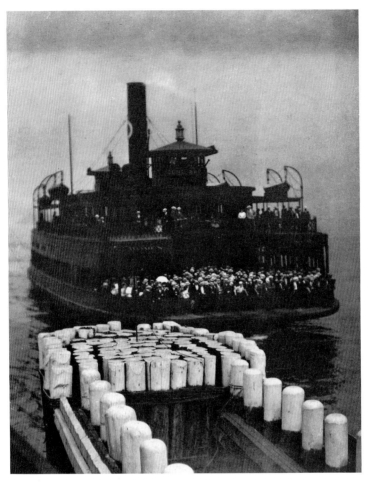

19 Alfred Stieglitz,
The Ferryboat,
photogravure,
1910

minute film resulted from a 'very close and fluid experimentation' between the two artists.[94]

Downtown Manhattan was a natural subject for these two modernists living in America's premier metropolis. The city's most distinctive feature was its unique skyline at the tip of the island. The invention of self-supporting steel frames and electrically powered elevators had made feasible the construction of extremely tall buildings, and some had already risen as high as sixty storeys. Furthermore, a construction boom in the first two decades of the twentieth century spawned an extraordinary number of new skyscrapers, seemingly overnight. The concentration of these architectural giants in downtown Manhattan symbolized a brave new world of up-to-date modernity, unparalleled in any other country.

Sheeler and Strand's vision of the city in *Manhatta* captures this sense of mesmerizing contemporaneity, and in order to do justice to their subject, the two artists focused intensely on innovative formal concerns. Incorporating multiple perspectives, abstract shapes, and fragmented views, they dislodged the urban monuments from any familiar context. To achieve this, they filmed the skyscrapers of lower Manhattan from extreme angles – either looking up from street level or looking down from the buildings' rooftops. These unconventional perspectives obliterate the horizon and also make the skyscrapers appear to shoot up or down through imploded space. In addition, each shot lasts for only a few seconds, which creates a disconnected and jumbled temporal progression. These cinematic techniques therefore disorient and dazzle the viewer, and the vortex of spectacular images simulate the intense, constantly changing impressions of the contemporary urban environment. As Strand described in a press release publicizing the film: 'The photographers have tried to register directly the living forms in front of them and to reduce through the most rigid selection, volumes, lines, and masses, to their intensest terms of expressiveness.'[95]

Manhatta lacks an overt plot, but it does illustrate a typical day in the metropolis.[96] A ferry's arrival in New York heralds the beginning. Views of Brooklyn Bridge, the busy harbour, railroad yards, downtown skyscrapers, and buildings under construction mark the day's progression. The sun setting on the Hudson River completes the visual journey. Intertitles taken from Walt Whitman's poems, 'A Broadway Pageant', 'Crossing Brooklyn Ferry' and 'Mannahatta', punctuate the urban imagery. From the first intertitle, 'When million-footed Manhattan unpent, descends to its pavements', to the last, 'Gorgeous clouds of sunset! Drench with your splendor me or the men and women generations after me',[97] the Whitman quotes provide an epic verbal complement to the scenes.

Although dating from the nineteenth century, these intertitles make sense within the context of an avant-garde American film because in modernist circles of the time, Whitman was revered as a spiritual forefather.[98] He was an important model because his poetry was virtually the first to explore the viability of ordinary American people and everyday American things as artistic subjects. He found aesthetic inspiration even in the country's urban and industrial domains. In 'Man-

nahatta', Whitman praised the 'Numberless crowded streets, high growths of iron, slender, strong / light, splendidly uprising toward clear skies . . .',[99] and in 'Crossing Brooklyn Ferry' he exhorted foundry chimneys to 'Burn high your fires.'[100]

Unlike Sheeler and Strand's interpretation of the city, however, Whitman's poetry places humanity at the centre of urban experience. In 'Song of the Broad-Axe', the poet proclaims:

> What do you think endures?
> Do you think a great city endures?
> Or a teeming manufacturing state? or a prepared
> constitution? or the best built steamships?
> Or hotels of granite and iron? or any chef-d'œuvres of
> engineering, forts, armaments?
>
> Away! these are not to be cherish'd for themselves,
> They fill their hour, the dancers dance, the musicians
> play for them,
> The show passes, all does well enough of course,
> All does very well till one flash of defiance.
>
> A great city is that which has the greatest men and
> women,
> If it be a few ragged huts it is still the greatest city in the
> whole world.[101]

Despite Whitman's role as mentor to Sheeler's generation of modernists, the rousing humanism of this passage marks a gulf between the poet's nineteenth-century perspective and later artists' depersonalized attitude towards urban forms in the twentieth century.

Indeed, Sheeler and Strand diminish and displace the human subject in a way that Whitman never envisioned. *Manhatta* does include bustling crowds; the opening sequence shows commuters departing from a boat, a scene reminiscent of Stieglitz's photograph, *The Ferryboat*. But in the cinematic ferryboat sequence, urban anonymity takes on an increasingly anxious edge. An isolated individual struggles against the overwhelming crowd moving in the opposite direction. It threatens to engulf him in its united but seemingly mindless will. In other sequences, however, the film presents humanity in a more detached way. It objectifies these characters; they appear to be mere swarms of ants viewed from the tops of skyscrapers, devoid of individuality and overpowered by the

massive buildings towering over them. In Peter Conrad's view, 'Theirs is a geometer's New York of sharpened edges and extreme angles, a city which, in the process of rebuilding, can be seen recomposing itself abstractly, purged now of Whitman's organic ferment.'[102]

The machine definitively triumphs over humanity in *Manhatta*, but nature – despite Conrad's assertion – is still an organic force that counteracts the hard, aggressive forms of bridges, trains, and skyscrapers. In some sequences, misty clouds of steam and smoke soften the geometricized cityscape. And the film concludes with a tranquil image of the sun shimmering on the harbour. As in Stieglitz's *Flatiron Building*, nature appears as the embracing context for the machine-age metropolis. Sky and sea seem to bolster and legitimize urban life, yet for the most part, the human population is diminished or conspicuously absent.

Despite *Manhatta*'s complex and disturbing portrayal of the urban populace, the film is, I believe, Sheeler's most positive treatment of a machine-age subject. In his subsequent work, the artist never again expressed a Whitmanesque optimism towards his subjects, nor did he repeat the use of nature to soften his depictions of urban modernity. In fact, the film's naturalization of the metropolis may be due to Strand's role in the project. Although Sheeler initiated the film, the imagery is much closer stylistically and thematically to Strand's earlier work than to his own.[103]

This first collaboration with Strand was also the last, and in fact, Sheeler abandoned film-making after *Manhatta*, while Strand went on to create many distinguished cinematic works. But the film made an immediate impact on Sheeler's career. He printed fifteen photographs reproduced from film stills, publishing five of them in *Vanity Fair* in 1922 (illus. 17).[104] And while he was making the film, Sheeler simultaneously photographed some of the same buildings from identical vantage points. He did not recreate the film's crowd or harbour scenes, however, and his New York photographs are therefore completely denatured and depopulated. Now the iconic buildings appear isolated from both nature and human use.

Shot from the top of the forty-one-storey Equitable Building, *New York, Park Row Building* (illus. 20) is perhaps the most intriguing of these photographs.[105] One of its peculiar features

is the relative anonymity of its subject. Many more easily recognizable buildings filled downtown Manhattan at the time Sheeler took this photograph. The Woolworth Building, for example, lies just west of the Park Row Building. Instantly identifiable, it was then the most prominent spire in lower Manhattan's skyline. Sheeler ignores it here but does include it marginally in another photograph in the series, *New York, Towards the Woolworth Building* (illus. 21). More comprehensive than *Park Row Building*, this photograph nevertheless severely truncates the Woolworth Building at the left of the composition. By cutting off its distinctive, Gothic crown, Sheeler renders it almost as anonymous as the Park Row Building itself.

The strange, undulating rear walls of the Park Row Building are probably what attracted Sheeler's interest, and he concentrated on these three utilitarian vertical shafts rather than on its more conventional façade with its classically inspired ornament and winged allegorical figures. The peculiar shafts undoubtedly came about in an effort to admit more light into the myriad windows that punctuate the rear of the building. But Sheeler's photograph reveals that many of the windows in the canyon-like crevices remain in permanent darkness. Also, a nearby skyscraper (perhaps the Equitable Building from which Sheeler took the photograph) casts a massive shadow that further prohibits light from reaching the building and those surrounding it. Ironically, the shaft that receives the most light has only a single, isolated window near its base. And beyond the roofs of smaller buildings in the foreground, a crane appears, indicating new construction. Another skyscraper will soon crowd into this already densely packed urban fabric. After its completion, even less light will reach this human-constructed canyon of steel and concrete.

Sheeler approached skyscraper subjects more conventionally in commercial photographs. His commissioned work, such as the illustrations for Lay's article on New York architecture (illus. 16), generally focused on the most distinctive features of the buildings, resulting in more easily recognizable views of landmark skyscrapers. But in his more experimental work, he either chose relatively anonymous buildings or fragmented the more famous structures, sometimes beyond recognition. His idiosyncratic approach enhanced the aesthetic modernity of his compositions, removing the subjects from

20 *New York, Park Row Building*, photograph, 1920

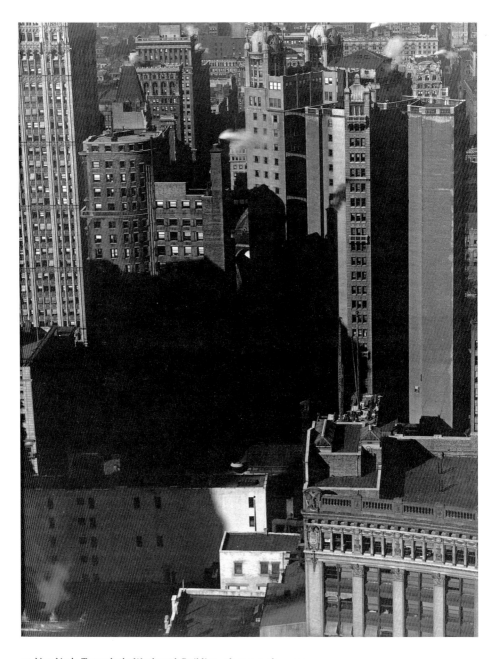

21 *New York, Towards the Woolworth Building*, photograph, 1920

the realm of banal tourist snapshots.[106] In fact, the magazine *Vanity Fair* published *Park Row Building* in 1921 without identifying the skyscraper at all. Instead the caption refers to the whole composition as 'Cubist Architecture in New York'.[107] Sheeler's fragmenting, decontextualizing presentation overshadows the identity of the individual buildings, allowing his contemporaries to see, as Picabia had announced earlier, that Manhattan is a ready-made modernist work of art.

An extended text accompanied the reproduction of *Park Row Building* in *Vanity Fair*:

> The artist felt, in the subject before him, the beauty of the architectural forms that have been created in New York to meet the fundamental necessity of providing buildings with the greatest cubic area upon the smallest possible base. He feels that, because our skyscrapers and loft-buildings have been created with the adequate solution of a necessity in mind, they . . . are our most vital contribution to architectural progress.[108]

This interpretation of New York skyscrapers resembles the rhetoric of Charles Downing Lay. Skyscrapers are one of America's most impressive indigenous achievements. Sheeler's stated intention is to reveal their beauty and vitality. The summary of the artist's ideas in this caption also indicates his conversance with the concept, much discussed in vanguard circles of the time, that beauty results when a useful object is designed as a straightforward solution to a practical problem. In emphasizing the unornamented rear of the Park Row Building, the artist interprets this concept with a modernist emphasis on the structure's stark, reductive, geometric forms.

Sheeler's reported objectives, however, are also somewhat at odds with the image itself. By representing the building from such an idiosyncratic and oblique angle, Sheeler obscures its function. We cannot tell whether it is an office or an apartment building. Furthermore, the urban fabric appears fragmented, overcrowded and robbed of light. Although strikingly beautiful, the image does not represent an ideally functioning cityscape.

Does this disparity indicate a level of conscious or unconscious critique in Sheeler's New York photographs? Do the images themselves convey a covert message that contradicts

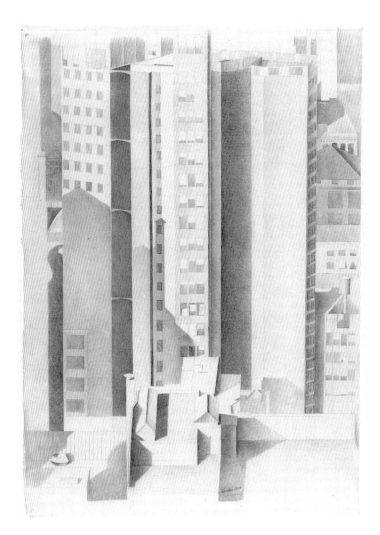

the artist's public statements? On one level, the works illus-
trate Mumford's concern for the way industrial culture and
urban forms dehumanize city dwellers. Sheeler eschews the
honky-tonk, billboard-plastered stretches of Broadway, but
his work does explore the implications of an urban environ-
ment that results from sole devotion 'to the production of
T-beams'. Such a place is dazzling to behold but accommo-
dates itself little to human needs for light, air and unrestricted
movement.

These troubling implications emerge even more strongly in
Sheeler's paintings and drawings of skyscrapers. Shortly after
making the photograph *Park Row Building*, the artist produced

a large pencil drawing, *New York* (illus. 22), with a very similar, if more abstract, composition. Two years later, he completed a painting, *Skyscrapers* (illus. 32), which is very close to the earlier photograph and drawing but eliminates even more details. The shaft at the right has become an almost completely abstract monolith. Even the solitary window has disappeared. The space is shallower, and the shadows are now concrete entities, almost as solid as the buildings themselves. The architectural planes loom more simply and assertively. Nothing natural grounds this horizonless vision of the metropolis.

Because of its increased abstraction, *Skyscrapers* may seem to offer little social commentary. But the painting's first owner, Duncan Phillips, interpreted it explicitly for its relevance to urban life:

> To express the impersonal character of his epoch [Sheeler] withdraws behind the scenes under consideration and reduces to the bare elements of design what he sees or photographs with his sharp lens. . . . His picture of an office building is more than a handsome pattern of exhilarating colors. Its soaring planes of gleaming masonry are broken here and there with innumerable little windows staring at us out of a glare of sunlight. Shafts of shadow and apertures of escape out of the steel-bound canyon afford relief and at the same time increase our sensation of being involved in a dream-like experience.[109]

As Phillips suggests, the windows in the central shaft, with their shades pulled up or down in various positions, do register different possibilities of openness and closure. But do they offer release? Does any feature in the work suggest an alternative to the 'steel-bound canyon' that completely fills the frame and, by implication, extends beyond it? The viewer wonders, peering into the black interior beyond the shaded windows, how anyone could inhabit such a building containing only void-like spaces. Phillips correctly sees that Sheeler's work expresses 'the impersonal character of his epoch', and he finds the resulting patterns and planes 'exhilarating'. But this presentation downplays human associations to such an extent that even the artist himself 'withdraws behind the scenes'.

Similar features appear in another painting from this period, *Church Street El* (illus. 33), based on a film still from *Manhatta*

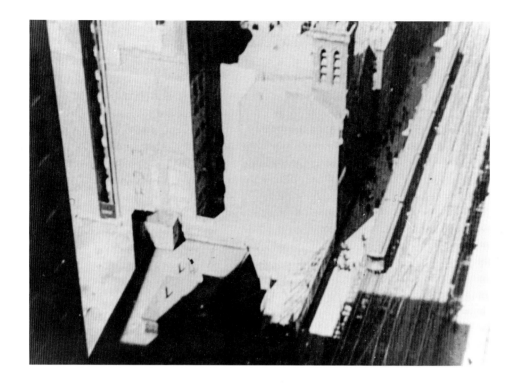

(illus. 23). From the Empire Building at 71 Broadway, we look down from a detached, omniscient perspective at the boundary of the historic, early nineteenth-century Trinity Church precinct – site of the oldest Episcopal parish in New York City. At upper centre, a truncated Georgian steeple sits atop the Sexton's Office associated with the church.[110] A train on elevated tracks moves diagonally at the upper right. The simplified, monolithic commercial skyscrapers and modern transportation route rise up on every side to dominate the more human-scaled, religious building.

23 *Manhatta*, film still, 1920

Again, Sheeler fragments and depersonalizes the structures. Instead of featuring nearby Trinity Church, with its famous Gothic spire, Sheeler focuses on the more anonymous Sexton's Office – one of the most peripheral and least recognizable parts of the historic area. This fragmentary view accentuates the fact that the surrounding skyscrapers have completely engulfed the older religious buildings. In the painting, the blank walls of the Sexton's Office and the neighbouring building to the left appear as attractive abstract planes. But the original still from *Manhatta*, on which *Church Street El*

was based, shows them to be raw and unsightly. Undoubtedly, another building had once abutted them. Now torn down, this absent structure leaves an ugly gash in the urban fabric. Evidence of construction already appears in the empty lot, however. Quite likely, a new and larger skyscraper will soon take its place.

Compared to the painting, the image from the film reveals a less attractive side to New York's unmitigated commitment to commercial expansion. It corroborates the observation of the literary critic Van Wyck Brooks in 1918:

> All our towns and cities, I think, have this family likeness and share this alternating aspect of life and death – New York as much as the merest concoction of corrugated iron and clapboards thrown together beside a Western railway to fulfill some fierce evanescent impulse of pioneering enterprise. Like a field given over to fireworks, they have their points of light and heat, a district, a street, a group of streets where excitement gathers and life is tense and everything spins and whirls; and round that lie heaps of ashes, burned-out frames, seared enclosures, abandoned machinery. . . .[111]

But this process of continual urban transformation was not disturbing to all observers. For example, Duchamp declared when he arrived in the city: 'I believe that your idea of demolishing old buildings, old souvenirs, is fine. . . . We must learn to forget the past, to live our own lives in our own time.'[112] But what does Sheeler's painting, which effaces but does not completely mask the destructive aspects of urban change, suggest about this phenomenon?

Like the New York photographs, Sheeler's *Church Street El* remains difficult to interpret. Are we meant to mourn the eclipse of history and tradition it records? Or to see ourselves as a new, omniscient race of monument builders, with perceptual abilities as dynamic as the city itself? Does the machine age release us from the need to perpetuate older, communal forms of architecture? Does the image invite us to worship at new altars – cathedrals consecrated to commerce rather than to religion?

One approach to the puzzling, indeterminate nature of this work is to see it as not only commenting on the external aspects of the city but also as being concerned with the

psychological dimension of urban experience. In other words, *Church Street El* represents more than just an aggressive hodge-podge of tall buildings. The image also suggests an urban state of mind – one radically modern, impersonal, and distinct from the mental outlook that moulded the art and life of earlier periods. As in *Manhatta*, vertiginous perspectives, disjunctive forms, and dehumanized settings convey a radically new experience of life in the modern metropolis.

Since the nineteenth century, creative individuals have attempted to delineate the city's transformative effect on human psychology, as in Edgar Allan Poe's tale 'The Man of the Crowd' and Charles Baudelaire's essay 'The Painter of Modern Life'. In academic writing, the German social theorist, Georg Simmel, was an important voice in the early twentieth century. His classic essay of 1903, 'The Metropolis and Mental Life', describes the unique psychophysiology that emerges in the modern urban setting:

> The psychological foundation, upon which the metropolitan individuality is erected, is the intensification of emotional life due to the swift and continuous shift of external and internal stimuli. . . . Lasting impressions . . . consume, so to speak, less mental energy than the rapid telescoping of changing images . . . and the unexpectedness of violent stimuli. To the extent that the metropolis creates these psychological conditions – with every crossing of the street, with the tempo and multiplicity of economic, occupational and social life – it creates in the sensory foundations of mental life . . . a deep contrast with the slower, more habitual, more smoothly flowing rhythm of the sensory-mental phase of small town and rural existence.[113]

The city's intense sensory excitation exacts a price, however, and a distinctively defensive psychology evolves in order to cope with urban over-stimulation:

> Thus the metropolitan type . . . creates a protective organ for itself against the profound disruption with which the fluctuations and discontinuities of the external milieu threaten it. Instead of reacting emotionally, the metropolitan type reacts primarily in a rational manner, thus creating a mental predominance through the intensification of consciousness. . . .[114]

This adaptation to urban life fosters extreme rationality over

emotionalism; impersonality and anonymity dominate over individuality and autonomy:

> . . . It need only be pointed out that the metropolis is the proper arena for this type of culture which has outgrown every personal element. Here in buildings and in educational institutions, in the wonders and comforts of space-conquering technique, in the formations of social life and in the concrete institutions of the State is to be found such a tremendous richness of crystallizing, depersonalized cultural accomplishments that the personality can, so to speak, scarcely maintain itself in the face of it.[115]

For Simmel, urban life above all else creates a conflict between the individual's desire to preserve autonomy and the demands of an environment that imposes standardization and anonymity.

During this period, American observers of the city – even in popular writing – often spoke in terms similar to Simmel's theories. In a 1909 guidebook to New York, John Van Dyke wrote that 'in a swift-expanding city like New York everything is more or less confused by movement, by casual phenomena, by want of definition. Self-imposed barriers are necessary to keep one from being lost in the vastness of the swirl.'[116] Waldo Frank, a literary critic in the Stieglitz circle, felt that the depersonalization imposed by the city was the most severe in America:

> Our centers of civilization differ from those of Europe in this: that they are cities not so much of men and women as of buildings. The imperious structures that loom over us seem to blot us out. And if our life is vital, we win our knowledge of it rather in what oppresses us than in ourselves. Indeed, we have lavished our forces altogether on the immensities about us, turned our genius into steel and stone, and to these abdicated it. There is a chasm between the created thing and the creator; and everywhere we are the underling and the unformed. We find ourselves smaller than our buildings. . . . To an astonishing degree, we have objectified our lives.[117]

If Frank's analysis is true, we would expect to find – as Albert Gleizes did – that American artists of the urban scene are among the most self-effacing and impersonal of the era.

Most modernist images of the city, in fact – both European and American – suggest elements that correspond to these analyses. They display an accelerated tempo, multiplicity of urban perceptions, and a triumph of impersonal values. In Léger's *The City* (illus. 2), for example, Paris is transformed into a fragmented, disjunctive arena of semi-abstract forms and symbols. Amidst this colourful, chaotic milieu, the grey men descending the stairs are faceless automatons, stripped of all individuality. The human subject disappears almost entirely in most urban imagery of the period. Such is the case with John Marin's *Lower Manhattan* (illus. 24). Like *Church Street El*, the disjointed, cubistic buildings, indicating the dynamic perceptual intensity of urban life, overwhelm the anonymous crowds at street level.

Church Street El is even more detached and impersonal than *Lower Manhattan*, however. Sheeler's cityscape presents a rather anonymous group of generic buildings, while Marin's

24 John Marin, *Lower Manhattan*, water colour, graphite, charcoal, paper cutout and thread, 1920

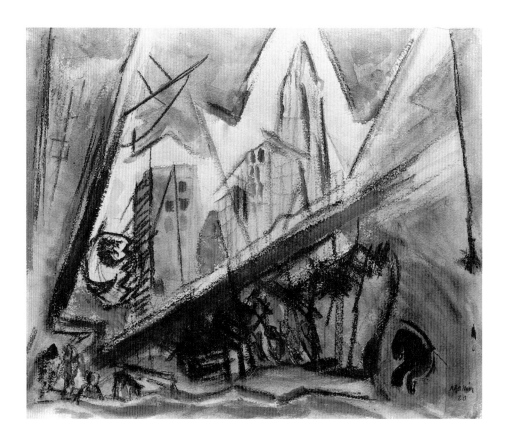

work invokes the most famous tourist landmark in New York, the Woolworth Building. Although Marin does not emphasize the human subject in his image, his active, gestural use of crayon and pigment invests the skyscrapers with personal, emotive intensity. The work dynamically expresses the artist's view of New York skyscrapers as living things. In contrast, the forms in Sheeler's painting are crystalline, precise and hard-edged; the mood is coolly deadpan. As he explained in 1923, he wanted to endow his subjects, not with anthropomorphic vitality, but with 'the absolute beauty we are accustomed to associate with objects in a vacuum'.[118] Therefore, *Church Street El* more strongly represents the rational detachment that Simmel perceived in a 'culture which has outgrown every personal element'. As the photographer Edward Steichen once declared, 'Sheeler was objective before the rest of us were',[119] implying that the artist had precocious knowledge of the machine age's psychological ramifications.

Although Stieglitz and Strand's photographs of the 1910s (illus. 18–19) address issues of anonymity and mass conformity in the urban context, Sheeler's city scenes mark a dramatic increase in the depersonalization of this subject. In Sheeler's art, we see the urban environment as Frank viewed it. The buildings overwhelm and figures vanish completely; in fact, human activities, emotions and values seem to have little place at all.

Yet although these early presentations of the city address issues of depersonalization and anonymity, Sheeler's developing style during this period was becoming paradoxically more and more distinctive. Indeed, in order to be considered a worthy modernist, an artist like Sheeler had to formulate a unique signature style. Since the late nineteenth century, the modernist movement had increasingly fostered personal stylistic individuation. This urge to innovate was no doubt intimately related in inverse proportion to the growing mass conformity of rapidly urbanizing Western societies.[120] And in this regard, metropolitan anonymity paradoxically assisted the modern artist's attempts at self-definition through stylistic innovation. As Simmel notes, the impersonal city tolerates forms of eccentric expression that would not generally arise in more tightly knit, rural society. The metropolis 'assures the individual of a type and degree of personal freedom to which there is no analogy in other circumstances'.[121]

The city thus provided a dialectical stage for modern artists' creativity during this period. On the one hand, its anonymous social fabric challenged traditional humanist notions of personal autonomy and uniqueness. It therefore stimulated artists to individuate themselves through stylistic innovation. On the other hand, the city provided an anonymous social setting that tolerated and sometimes even rewarded innovative and idiosyncratic creative acts.

Herein we find an essential underlying tension in Sheeler's imagery. His subjects imposed personal effacement and self-objectification as a norm, but the values of his artistic context called for innovation and individuation. Sheeler's works register these conflicts in their diminished human associations while, at the same time, they convey these qualities in a style that was unique to the artist – one so exaggeratedly impersonal, in fact, that it paradoxically became instantly recognizable as his own.

Throughout the 1920s, Sheeler continued to grapple with these conflicting agendas. He increasingly depersonalized the associational aspects of his works and also gradually abandoned an overtly Cubist-inspired style. He developed a more austere, realist idiom, and his paintings became increasingly dependent on his photographic practice. This approach produced stunning results, which culminated at the end of the decade in works such as *Upper Deck* (illus. 34).

The painting depicts pristine electric motors and ventilator stacks on the deck of a German ocean liner, the SS *Majestic*. In composition, the work almost exactly duplicates an earlier commissioned photograph of the same subject (illus. 25). In contrast to *Church Street El*, the forms are not disjunctive or fragmented. Each object appears in a coherent, logically ordered space clearly and crisply illuminated by harsh, bright light. In its strong, geometric clarity, however, this work relies heavily on the artist's earlier experiments in abstraction. As Sheeler explained, he slowly discovered that 'pictures realistically conceived might have an underlying abstract structure'.[122] In this respect, *Upper Deck* emerged as a watershed in his career and set the direction for his subsequent work in the 1930s.

From 1923 to 1929, Sheeler worked almost exclusively for Condé Nast and for various advertising agencies, leaving little time for his painting practice. His consuming involve-

ment with commercial photography in the 1920s perhaps
inspired this move towards greater realism and objectivity in
his painting. This stylistic development may also have been
a way of further stating his allegiance to machine-age values,
as Susan Fillin-Yeh has argued.[123] On an overt level, the
impersonal, smooth surfaces devoid of brushstrokes, as well
as the hyperrealism of these paintings, seem to assert an
ideal of image-making parallel to the precision of mechanical
reproduction through photography. And the works' intense
verisimilitude increases the appearance of artistic self-
effacement. As Sheeler stated in 1939, he developed this style
because of a 'desire to remove the method of painting as such
from being a hindrance in seeing'.[124]

The artist even applied this personal version of the machine aesthetic to works such as *Americana* (illus. 35), which seem on the surface to have nothing to do with the machine age. Throughout the 1920s and 1930s, Sheeler painted still lifes and domestic interiors in this manner.[125] *Americana* depicts Sheeler's own home and the handmade, vernacular objects that he collected: rag rugs, a ladder-back chair, a Shaker table, an oval box, and a bread tray. Yet the artist rendered this subject in the same hard-edged, self-effacing style as he employed in *Upper Deck*. Therefore, the objects in both works seem intimately related in their spare, boldly abstract, unornamented, and functional forms. Such were the totalizing effects of Sheeler's machine aesthetic: both technologically sophisticated machines and preindustrial artifacts are made to appear as essentially the same.[126] The machine age encompassed everything within its domain.

Despite its impersonal and totalizing implications, however, Sheeler's hyperrealist machine aesthetic *was* a signature style, quite unique among American modernists when he evolved it in the late 1920s.[127] It answered, at least in the context of his American contemporaries, to the demands for modernist originality because it was distinctively his own. At the same time, it well conveyed the associations of anonymity and self-effacement he sought to project both in his artistic persona and in his presentation of urban, technological, industrial and even preindustrial subjects. During the 1920s and early 1930s, Sheeler was able to keep these contradictory agendas balanced; but, as we shall see in a later section, internal conflicts and changed social circumstances in the late 1930s began to undermine the artist's efforts to maintain this synthesis.

Although Sheeler continued to photograph skyscrapers throughout the decade, he produced few paintings and drawings of them after 1922. In fact, from that point on, urban scenes make up a surprisingly small part of his non-photographic work. The last skyscraper he depicted during this period was the Delmonico Building (illus. 26), erected in 1926 at the north-east corner at Forty-fourth Street and Fifth Avenue. The building's name derived from the fact that, until 1925, a six-storey structure housing the famous Gilded Age eating establishment, Delmonico's, had occupied the site. Preservation-minded New Yorkers mourned the passing of this elaborately decorated landmark building,[128] and one

architectural critic savaged the skyscraper, designed by H. Craig Severance, that rose in its place. A critic for *The New Yorker* claimed that 'its central tower . . . has the grace of an overgrown grain elevator'.[129] To a functionalist architect, this comparison would have been a compliment![130] But Severance successfully sued *The New Yorker* for damages, and the controversy about the building lingered on throughout the 1930s.[131]

Sheeler based his composition for the lithograph *Delmonico Building* on his contemporaneous photograph of the same structure published in *Vanity Fair* in November 1926 (illus. 27).[132] In both Sheeler's presentations, the building's towering, set-back central shaft soars above the smaller structures surrounding it, indicating an awareness of the structure's controversial and bold emergence in the city's older, more genteel fabric. As in Sheeler's earlier skyscraper images, the perspective on the scene is idiosyncratic. We look at the blank, unornamented rear from Madison Avenue towards Fifth. (The Delmonico Building would presumably soon have an equally tall neighbour abutting it; therefore, it seemed unnecessary for the architect to ornament this elevation.) As in *Park Row Building*, no entranceway is visible, and Sheeler almost completely ignores the more ornamented parts of the building. In addition, the smaller structure at the bottom of the composition displays raw, uneven brickwork and exposed iron pins where an adjacent structure had once abutted it. Undoubtedly, this absent building, like the original Delmonico restaurant, had been demolished to make way for a larger, more up-to-date structure. This makes the work, like *Church Street El*, another meditation on the unbridled commercial expansion that continually eclipses New York's past.[133] As Van Dyke wrote in his guidebook to the city, 'Everything sooner or later resolves itself into a matter of finance, especially in New York; and things must "pay", otherwise they will not last for long.'[134]

In the diagonal orientation of the composition, *Delmonico Building* also resembles *Church Street El*. In the later work, however, the view is from street level looking up; the building rushes away from the observer on a dynamic axis, accentuated by the tall, dark building to the right. Here Sheeler renders the forms in a more realist manner, in keeping with his stylistic development of the latter part of the decade. The meticulous details, the central shaft dissolving into a void-like space,

26 *Delmonico Building*, lithograph, 1926–27

27 *'On the Site of Historic Delmonico's'*, reproduced from *Vanity Fair* (November 1926)

the subtle tonal variations, and the delicate texture of the lithographic crayon all convey a feeling very different from the disjunctive, Cubist-inspired elements in *Church Street El*. Here also Sheeler brings the energy of the city more under control. And unlike *Church Street El*, which emphasizes the anonymous urban fabric, this work is definitely a portrait of a specific building. However, as in *Park Row Building*, the artist presents the most anonymous elevation, and it would be hard to identify it without the title because of this eccentric angle.

Stylistic differences distinguish *Delmonico Building* from Sheeler's earlier skyscraper subjects. But continuities exist as well, for example, the repeated focus on blank walls. In all the images, this choice does double duty, both formal and

28 Charles
Demuth,
Business, oil, 1921

thematic. Formally, it provides flat, abstract planes in the composition. In *Delmonico Building*, this is especially important because it reasserts Sheeler's modernist, abstract compositional strategies within his newly developed realist idiom. And thematically, these blank walls establish the city in dynamic transition – ever erecting new monuments to the machine age, ever destroying older, more historic structures.

These walls also suggest another, more metaphysical dimension. Like Charles Demuth's *Business* (illus. 28), in which the billboard-like calendar on the building's façade seems to advertise the routinized nature of the commercial activity inside, Sheeler's work demonstrates a fundamental hollowness. As Conrad writes:

Walls like these, in their very lack of signification, have a symbolic provenance in American art. They're the infinitudes of negative sublimity, a pallor that appalls, like the incomprehensible whiteness of Moby Dick or the uncharted extent of American geography, which weary human beings have to trudge across and fill up. The first task of the American painter is repletion of this emptiness; but his way of colonizing it is simply to color it white.[135]

Like pages of a book on which nothing is inscribed, these

featureless walls are 'as wide and as depressingly open as the continent they're meant to occlude'.[136]

Other images of the city, like Marin's *Lower Manhattan* (illus. 24) and Stella's *Brooklyn Bridge* (illus. 14), convey an exciting and glamorous mood far different from Sheeler's haunting skyscraper. Conversely, George Ault's *Construction Night* (illus. 29) shows more open hostility to New York than does Sheeler's *Delmonico Building*. Ault referred to the city as 'the Inferno without the fire' and to skyscrapers as 'tombstones of capitalism'.[137] Favouring night-time views, the artist also depicted the city in transition – a dark, ominous steel frame rises in the foreground. The harshly spotlighted buildings

29 George Ault,
Construction Night,
oil, 1922

with few windows stand prison-like, juxtaposed against the jet-black sky. Ault painted the city in a way that reflected his own 'psychic disquiet'.[138]

But Sheeler's skyscrapers leave us more vaguely disconcerted than terrified; only Demuth's architectural images approach them in their puzzling obliqueness. There is something subtly disturbing in the repeated presentation of windowless, monolithic walls and buildings devoid of access. Offering no obvious possibility of human use, these buildings appear as signs of some separate, unknowable existence. In the face of this, we, like they, are called upon to shroud ourselves in a defensive, depersonalized façade.

Sheeler has often appeared to critics as an unambivalent advocate of New York's modernity. Indeed, a sense of new discovery energizes his film *Manhatta* and other urban images of the early 1920s, and this tends to mask the subjects' disturbing implications. But in *Delmonico Building*, these unsettling undercurrents emerge more pointedly. Sheeler's experiences in New York had become increasingly difficult as the 1920s progressed, and some of this urban disillusionment undoubtedly affected his work, giving it a more sober cast. He had a falling out with Strand and Stieglitz over an article he wrote on Stieglitz's photographs in 1923.[139] They also considered him an artistic sell-out for devoting his talents to commercial practice after Sheeler began to work for Condé Nast. Sheeler's letters from this period indicate that he himself resented the time his commercial photography took from his painting practice. He complained about his advertising work to Walter Arensberg: 'I know little or nothing but my job which by this time has come to be like a daily trip to jail. . . . At any rate something has to be done to stir up the waters again to destroy present images. Contemplating them has grown too monotonous.'[140]

As the decade wore on, skyscrapers attracted Sheeler's attention less and less in his art, and his commercial photography became an increasing burden, producing monotony, alienation, and a feeling of imprisonment. At the end of 1926, Sheeler and Katharine finally moved out of the city and relocated in isolated, rural South Salem, New York. Although he continued to maintain a photographic studio in Manhattan until 1932, *Delmonico Building* was Sheeler's ambivalent, parting reflection on life in America's premier machine-age metropolis.[141]

Industry and Technology

In addition to the urban imagery of the era, sophisticated technological artifacts and large-scale industrial complexes emerged as exemplary machine-age subjects during the 1920s. Early in the decade, paintings such as Charles Demuth's *End of the Parade: Coatesville, Pa.* (illus. 30) began to establish a modernist norm for the representation of industrial scenes: semi-abstract, geometricized, and depopulated. Depicting a factory complex not far from Demuth's native Lancaster, Pennsylvania, the painting exhibits a densely packed and shallow pictorial surface. Flat, hard-edged smokestacks bellow polluting vapours into the atmosphere, while prosaic, unornamented brick buildings occupy the painting's peripheries. Understated Futurist 'lines of force' divide the sky into diagonal bands, and the formal ensemble suggests the inner workings of a machine itself. The texture of brushstrokes is hardly evident, which effaces the artist's role as maker of this handcrafted object. Furthermore, no sign of human presence appears, yet the painting's seemingly incongruous title informs us that the parade ends here. Where then are the marchers and onlookers? How are we to feel about this deserted factory as the final destination on the route of a nonexistent parade?

Shortly after the painting was completed in 1920, the art critic Henry McBride struggled to assess Demuth's attitude towards a subject that was extremely novel at the time. Calling the artist a 'caricaturist' who 'laughs at our architecture', McBride felt that when he paints 'a modern mill, with its lofty smoke-stacks and concrete . . . there is no doubt whatever that one side of Mr Demuth's nature is up in arms' But, the perplexed McBride concluded, '. . . the other side of him is pure artist, and the result, in spite of the concrete, is beautiful'. Obviously fascinated with the artist's elusive ambivalence towards the factory setting, McBride declared, 'The Coatesville Steel Mill is one of the most important pictures in modern American art'[142]

McBride's response to Demuth's work demonstrates how puzzling these American icons of industry were to certain

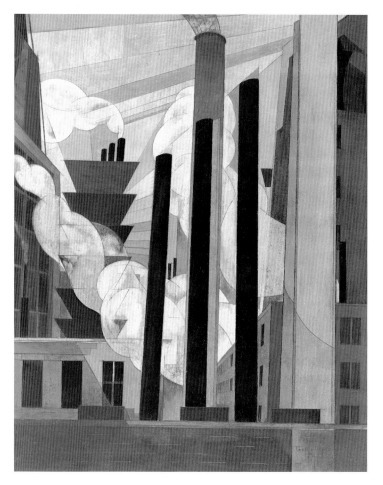

30 Charles Demuth,
*End of the Parade:
Coatesville, Pa.*,
tempera and pencil,
1920

viewers at the time, and how enigmatic they continue to be. Many contemporary artists selected seemingly unaesthetic subjects – such as factories, grain elevators, and steam turbines – and transformed them into cool, deadpan images of great power and beauty. At the same time, the artists themselves seemed to withdraw behind the smoothly painted, impersonal surfaces. As we shall see in this section, Sheeler's industrial scenes, such as *Classic Landscape* (illus. 37) and *American Landscape* (illus. 38), also exhibit this puzzling aloofness. Although Sheeler's paintings are less overtly ironic than Demuth's works, they are equally provocative and elusive. They epitomize the problematic nature of industry and technology as subjects in American art during this period.

Before the rise of the machine aesthetic in painting, social

theorists and cultural critics saw industrialization as one of the causes of diminished personal expression in contemporary society. Simmel felt that modern mass production, along with the conditions of urban life, contributed to objectifying consciousness:

> . . . The development of modern culture is characterised by the predominance of what one can call the objective spirit over the subjective. . . . This discrepancy is in essence the result of the success of the growing division of labor. . . . [The individual] becomes a single cog as over against the vast overwhelming organization of things and forces which gradually take out of his hands everything connected with progress, spirituality and value.[143]

The American sociologist, Thorstein Veblen, advanced similar ideas in 1906:

> In the modern culture, industry, industrial processes, and industrial products have progressively gained upon humanity, until these creations of man's ingenuity have latterly come to take the dominant place in the cultural scheme; and it is not too much to say that they have become the chief force in shaping men's daily life, and therefore the chief factor in shaping men's habits of thought. Hence men have learned to think in the terms in which technological processes act.[144]

Paul Rosenfeld saw the same processes at work in 1921, but responded with greater alarm:

> For a century, the machines have been enslaving the race. For a century, they have been impoverishing the experience of humanity. Like great Frankenstein monsters, invented by the brain of human beings to serve them, these vast creatures have suddenly turned on their masters, and made them their prey. It is not so much the fact that men have used these great implements in manufacturing that has manacled them, as the fact that the mass production permitted by the use of arms of steel has succeeded in mechanizing human life.[145]

To these observers, the machine age had spawned human beings whose emotional and mental lives now functioned in accordance with standardized industrial practices. All voiced

a prevalent view that the modern industrial system posed a challenge to traditional humanist values regarding autonomy, freedom and uniqueness in the individual.

Of course, not every observer believed in the efficacy of these values; Picabia's mechanomorphs gleefully deflated traditional concepts of the self, and Duchamp's ready-mades irreverently challenged humanist notions of personal authorship in works of art. But artists and critics who cherished the ideal of the self as a unique fountainhead of personal creativity were extremely distressed by the machine's influence on contemporary society. Van Wyck Brooks wrote in 1918 that Americans were especially vulnerable to 'the universally externalizing influences of modern industrialism'.[146] The American mind, he felt, 'has had no barriers to throw up against the overwhelming material forces that have beleaguered it. Consequently, it has gone out of itself as it were and assumed the values of its environment.'[147]

To Brooks, this accounted for why American artists effaced themselves before their subjects: 'Unable to achieve a sufficiently active consciousness of themselves to return upon their environment . . . and recreate it in the terms of personal vision, they gradually come to accept it on its own terms.' In American works concerned with industrial subjects, Brooks claimed that 'the machines themselves become vocal and express their natural contempt for a humanity that is incapable, either morally or artistically, of putting them in their place and keeping them there'.[148]

Brooks actually disapproved of the much-vaunted American individualism, however. He believed that it had prevented 'the formation of a collective spiritual life' and as a result American artists and intellectuals had most often become mere aberrant 'cranks'. As a remedy, he advocated the creation of a 'usable past' or new cultural history. This, he hoped, would give rise to a 'poetic' outlook – one that would encourage more original and self-possessed artistic expression.[149]

This line of thinking is akin to Randolph Bourne's contemporaneous concept of a 'new American nationalism'. But Bourne had a more radically individualistic focus than Brooks. He regarded personal autonomy as sacrosanct. 'The aim of the group must be to cultivate personality, leaving open the road for each to follow his own.'[150] He felt that a regenerated

social order would result only from the self-development and self-expression of the individual. The emancipation of personality – which would free creative individuals to form a utopian community – was the solution to the machine's pernicious domination of contemporary society. Bourne never resolved how an individual could function intimately within a social group and at the same time transcend its limitations and lead others to reformulate its structure.[151] Such unpragmatic idealism was nevertheless characteristic of cultural radicalism during the 1910s.

During a time when urbanization and industrialization posed real threats to individual autonomy, cultural radicals believed that artists were uniquely suited to lead society because they stimulated sensibility and emotional awareness in a public long deadened by the predominant materialism, standardization and commercialism of American life. Stieglitz's glorification of the artist's role exemplifies these beliefs. In 1916, he wrote that 'it is only through the artist that [the public] is helped to develop itself'.[152] America's involvement in the First World War, and the repressive social climate that followed it, somewhat dampened such idealistic assessments of the artist's ability to affect social regeneration, but Stieglitz and others in his circle remained attached to the idea of the artist as society's saviour. The fact that Stieglitz employed a camera as his expressive instrument was especially significant. 'For, in using the camera, he has demonstrated the power of man,' Rosenfeld declared. 'He has made the very machine demonstrate the unmechanicalness of the human spirit.'[153] Although Sheeler was a masterful photographer as well, his images, as we shall see, suggest a much less confident view of the artist's role in machine-age America.

Stieglitz and Bourne's cultish regard for individual artistic self-expression contrasts markedly with the progressive journalists and social reformers of the period, such as Walter Lippmann and Herbert Croly. They were less concerned with the individual than with the group and proposed the rational control of society by practical political means as a remedy for modern social and economic problems. These figures advocated installing a disinterested managerial élite in the government so that it could run industrialized America in the same way as corporate leaders like Ford had organized industry – in an efficient, orderly and scientific manner.

Croly especially distrusted 'the traditional American confidence in individual freedom' The modern era instead required 'a large measure of individual subordination and self-denial' along the lines imposed by corporate managers on employees.[154] In other words, being an anonymous cog in the machine of modern society was not such a bad thing because sacrificing individual interest to the corporate body created a healthier whole. Such progressive schemes involved, in Peter Ling's words, 'a seemingly limitless faith in the efficacy of applied expertise: a problem thoroughly studied could be solved.'[155] This faith in the effectiveness of the managerial élite persisted in government and business circles throughout the 1920s.

Like the progressives, many utopian modernists of the post-war era also welcomed the psychological and social transformations imposed by rational applications of the machine. In fact, they felt that an anti-individualistic orientation was necessary to the dawning of a new era. Le Corbusier and Amédée Ozenfant, for example, announced in 1918 that the war had 'tested everything, it destroyed senile methods and replaced them with those which the battle proved best'.[156] To these Purist artists, the new, triumphant methods were those advocated by Taylor in his system of scientific management and successfully employed by industrialists like Henry Ford. Le Corbusier optimistically believed that greater social justice would inevitably result from the adoption of such methods.[157] He declared, 'Big business is to-day a healthy and moral organism.'[158] For numerous utopian-minded artists of the era, pragmatic engineers rather than idiosyncratic dreamers would make the blueprints for a new society. They also believed that widespread implementation of advanced industrial practices could level differences between nations, bring about world unification, and thereby insure against another catastrophic world war.

Ford himself had no interest in modern art, yet he shared with these vanguard artists a similarly grandiose conception of industry's potential. In an article titled 'Machinery – The New Messiah', Ford claimed: 'Machinery is accomplishing in the world what man has failed to do by preaching, propaganda, or the written word. . . . Thus may we vision a United States of the World. Ultimately, it will surely come!'[159] In retrospect, Ford's predictions seem naïve and self-serving,

31 *Dahlias and Asters*, oil, 1912

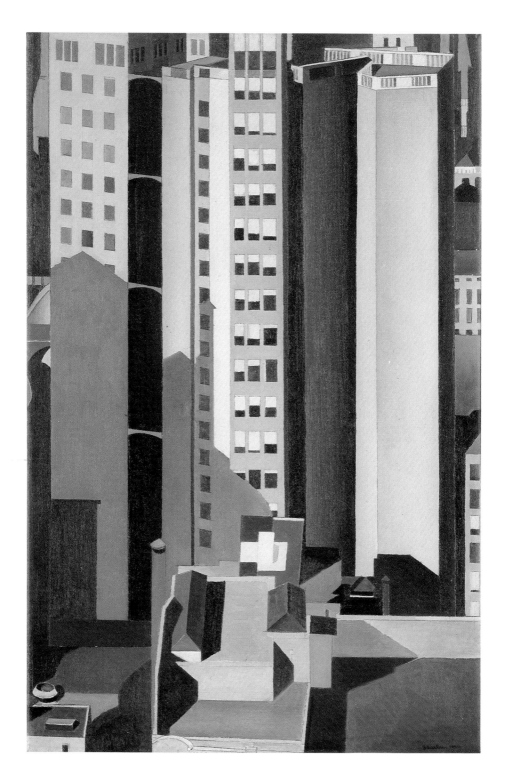

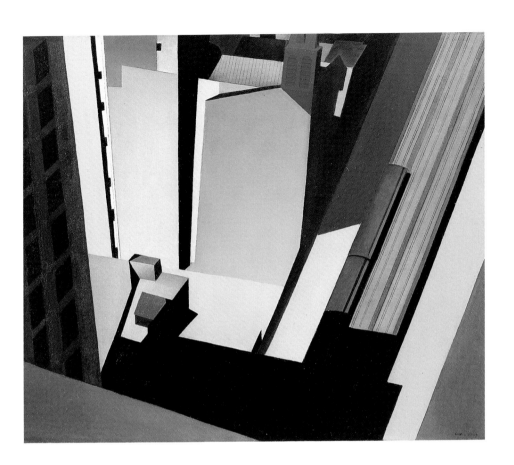

32 *Skyscrapers*, oil, 1922

33 *Church Street El*, oil, 1920

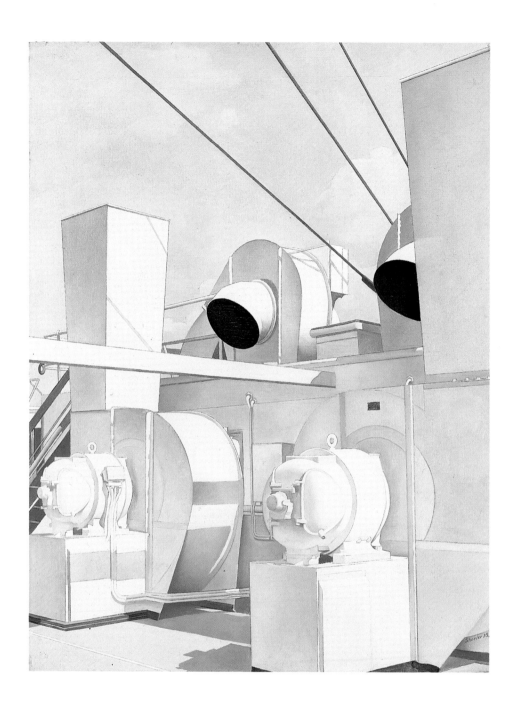

34 *Upper Deck*, oil, 1929

35 *Americana*, oil, 1931

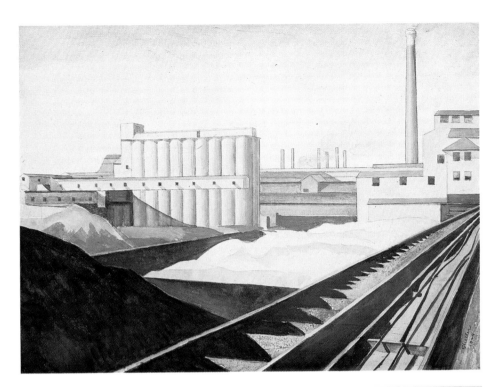

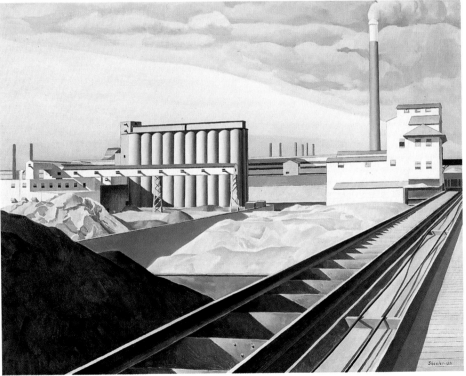

36 *Classic Landscape*, watercolour, gouache and graphite, 1928
37 *Classic Landscape*, oil, 1931

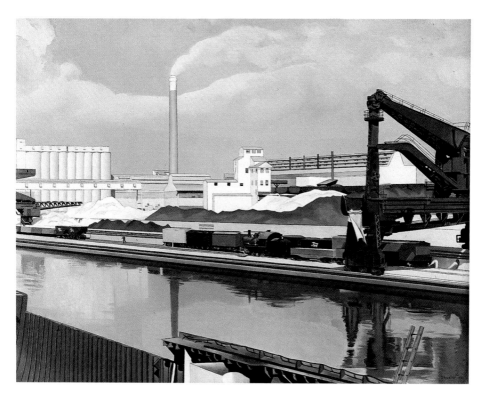

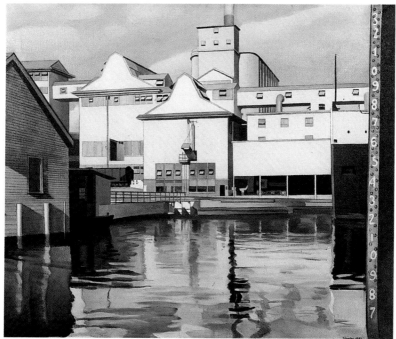

38 *American Landscape*, oil, 1930
39 *River Rouge Plant*, oil, 1932

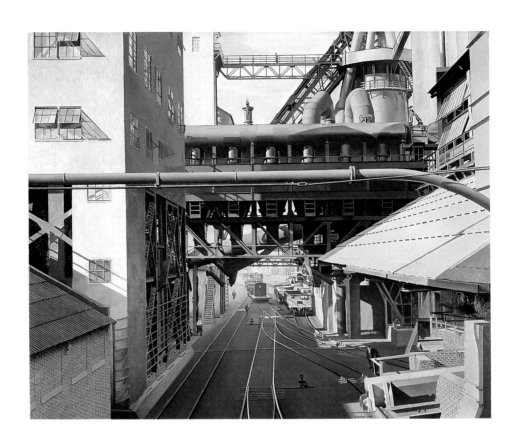

40 *City Interior*, oil, 1935

but the mythic underpinnings of the machine age made such conceptions seem plausible to many during the era.

Ford also embraced the emerging mechanistic attitude towards humanity; he even conceived of the body as consisting of interchangeable parts. 'There is every reason to believe that we should be able to renew our human bodies in the same manner as we renew a defect in a boiler,' he stated.[160] He freely admitted that the principles of mass production limited personal freedom in the labour force and even claimed that most workers welcomed such a situation: 'The average worker, I am sorry to say, wants a job in which he does not have to put forth much physical exertion – above all, he wants a job in which he does not have to think.'[161] Such remarks led Gramsci to state:

> It is certain that [American industrialists like Ford] are not concerned with the 'humanity' or the 'spirituality' of the worker This 'humanity and spirituality' cannot be realised except in the world of production and work and in productive 'creation'. They [existed] most in the artisan, in the 'demiurge', when the worker's personality was reflected whole in the object created and when the link between art and labour was still very strong. But it is precisely against this 'humanism' that the new industrialism is fighting.[162]

However exploitative and dehumanizing, Ford's attitudes were extremely expedient; they bolstered his dominance of the automobile industry for many years. In the process, regard for personal satisfaction in productive endeavours – at least for workers – was callously set aside.

Thus opinions about the machine's challenge to traditional humanistic notions regarding individual liberty and self-determination encompassed an enormous range during this period. The complexity of Sheeler's industrial subjects runs parallel to the deeply conflictual nature of these issues at the time. But on the most obvious level, his work seems to side with the supporters of a managerial élite. The artist's first engagement with industrial subjects in fact resulted from a public relations scheme intended to glorify Ford's aggressive expansionism.

In 1927, Ford transferred his operations from the outdated Highland Park plant to the Rouge River site about ten miles from Detroit. When completed, the Rouge became the largest

and most technically sophisticated manufacturing complex in the world.[163] A virtually self-sufficient industrial city, it consisted of 23 main buildings and over 70 subsidiary structures, 93 miles of railroad tracks, 27 miles of conveyors, 53,000 machines, and 75,000 employees.[164] All aspects of automobile production occurred at this industrial metropolis, from the smelting of steel to the final assembly of vehicles.

Competition from General Motors had forced Ford to abandon the Model T and develop a new, more stylish and marketable car. The Rouge plant produced the first Model A automobiles in December 1927, and the Ford Motor Company secured the services of N. W. Ayer & Son to stage a comprehensive promotional campaign for the new vehicle. As part of this campaign, Ayer commissioned Sheeler to make a photographic series of the Rouge plant, which would creatively interpret American industry. The photographs were used not only for Ford's publicity purposes, but Sheeler also published them independently as artworks.[165]

Sheeler spent six weeks at the River Rouge plant beginning in late November. The industrial complex immediately over-

41 *Production Foundry – Ford Plant*, photograph, 1927

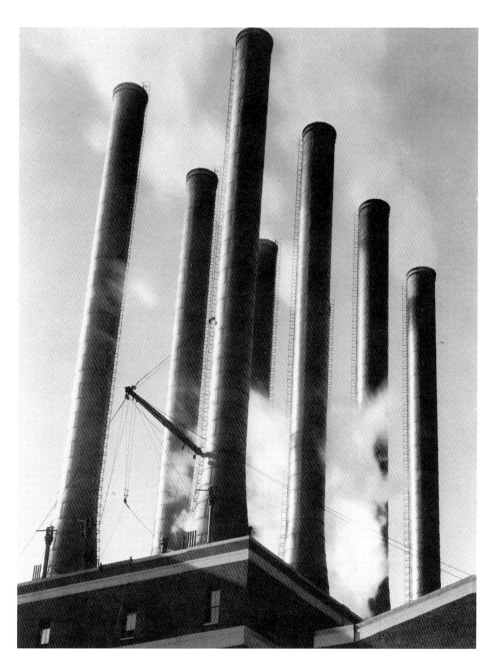

42 *Power House No. 1 – Ford Plant*, photograph, 1927

whelmed him, as he reported to his friend Walter Arensberg: 'The subject matter is incomparably the most thrilling I have had to work with.'[166] Sheeler produced thirty-two 'official' photographs for the Ford Motor Company,[167] but he also made many reference shots during his visit to the plant.[168]

The thirty-two official photographs are very selective in scope. They include a few overviews of the mammoth buildings, such as *Production Foundry* (illus. 41). The world's largest foundry at the time Sheeler took the photograph, the building rises majestically in the foreground; railroad tracks, cars and conveyors recede dramatically to the right.[169] Most of the shots, however, are close-up, detailed views, such as *Power House No. 1* (illus. 42). Sheeler here focuses on the tall, repetitive stacks silhouetted against the sky. Interior shots, such as *Ladle Hooks, Open Hearth Building* (illus. 43), present the massive enclosed spaces as soaring and cathedral-like, lit by a mysterious, glowing light – not unlike the illumination in Sheeler's early view of preindustrial equipment, *Interior, Bucks County Barn* (illus. 11). In both photographs, the light endows these utilitarian spaces with a sanctifying aura.

Workers rarely appear in the Rouge photographs. When they do, as in *Stamping Press* (illus. 44), the huge, complicated machinery overwhelms and isolates them. This kind of presentation was by no means new. Since the nineteenth century, photographs of factories had consistently presented workers as mere ciphers or appendages to machines.[170] To feature workers might reveal too much about the unpleasant aspects of factory labour and, in any event, the buildings and equipment were often the most significant aspects of the industrial enterprise from management's perspective. For example, at the Highland plant, opened in 1910, Ford engineers had evolved a new, rationalized 'architecture of production' that greatly enhanced the efficiency of the operation. The interlocking machinery and automatic conveyor belts not only improved productivity, but they also dictated the ways in which labourers would perform their work. The swiftly moving assembly lines severely limited workers' movements and their exercise of individual initiative. Now the factory embodied in its very structure the imperatives of management, whose wishes were conveyed, not merely by foremen, but by the architecture of the workplace.[171]

With the Rouge plant's sophisticated new equipment and

43 *Ladle Hooks, Open Hearth Building – Ford Plant*, photograph, 1927

44 *Stamping Press – Ford Plant*, photograph, 1927

buildings, engineers had further perfected control of labour through the working environment. But Sheeler's photographs avoided revealing such aspects of the factory's operation. Images that illustrated how the architecture and machinery imposed deadening, dangerous, and repetitive patterns of work would make too explicit the exploitative nature of managerial imperatives. Most likely, therefore, the advertising agency encouraged Sheeler to focus on the buildings in isolation, rather than on the hectic activity around the assembly line. Ayer undoubtedly understood that the company 'needed photographs of calm industrial grandeur that would express the nature of the enterprise as Ford wanted people to see it' – the River Rouge plant as one stupendous, perfectly functioning, self-operating machine.[172] In this case, Sheeler's already established habit of avoiding human subjects well suited the needs of his patron.

Criss-Crossed Conveyors (illus. 45) strikingly conveys the powerful allure of Ford's buildings when presented in isolation from human use. This photograph also recreates the myth of industry as the new religion of the machine age by focusing on the monumental grandeur of the factory buildings. (In fact, two years later, Sheeler photographed the converging buttresses of Chartres Cathedral [illus. 46] in a remarkably similar way.) Across a yard filled with train wheels, two conveyors carrying coke and coal loom assertively above the viewer, forming a dynamic 'X' in the centre of the composition. Other conveyors recede to the left, and eight tall stacks, seen in close-up in *Power House No. 1* (illus. 42), rise vertically in the background. The dense, polished forms of the industrial buildings gesture towards the sky like Gothic spires. Sheeler's vision of American industry in this photograph transforms the factory complex into an icon of omnipotence.

Vanity Fair published *Criss-Crossed Conveyors* in 1928 with a lengthy caption that concludes: 'In a landscape where size, quantity and speed are the cardinal virtues, it is natural that the largest factory, turning out the most cars in the least time, should come to have the quality of America's Mecca, toward which the pious journey for prayer.'[173] The magazine's ironic hyperbole satirizes the popular idealization of Ford's industrial metropolis, but perhaps the exaggeratedly awestruck prose also reflects some genuine admiration; Sheeler's stun-

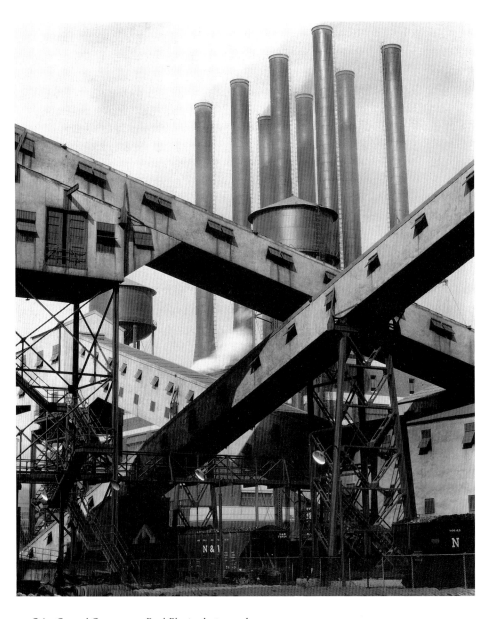

45 *Criss-Crossed Conveyors – Ford Plant*, photograph, 1927

ning image *is* seductively persuasive – a visual confirmation
of the cultish sanctification of industry during this period.

Sheeler's River Rouge series was apparently never exhibited
in its entirety, but the photographs – published individually
or in small groups – appeared in numerous journals in
America as well as in Europe, Japan, and Russia. Industrial
subjects were already well established in modern painting
and photography, but Sheeler's images set new standards for
the representation of such highly-charged iconography.[174]
The series also established the artist's own status as a leading
iconographer of the machine age. Ironically, these images
even won Sheeler a semi-official invitation from the Soviet
government to do a similar study of Russian industry.[175] The

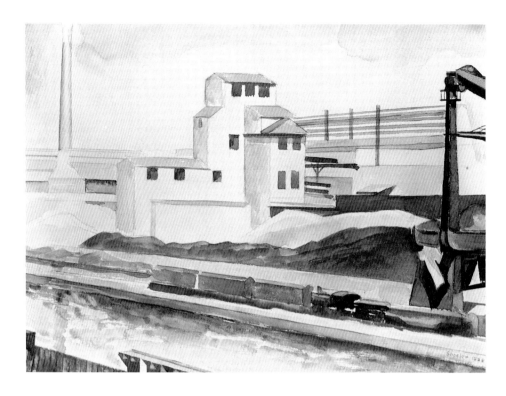

Soviet Communists apparently read the images as a politically neutral celebration of advanced technology and industrial practices, despite the subject's association with Ford's intensively competitive, capitalistic enterprise.

As with the film *Manhatta*, the River Rouge photographs stimulated the artist to adopt new subjects in his painting practice. Soon after his visit to Detroit, Sheeler produced several factory scenes: a watercolour, *River Rouge Industrial Plant* (illus. 47), and a lithograph, *Industrial Series # 1* (illus. 48). These served – along with reference photographs – as studies for Sheeler's first major oil painting of the Rouge, *American Landscape* (illus. 38), executed in 1930. In 1928, Sheeler also created a small watercolour drawing, *Classic Landscape* (illus. 36), undoubtedly based on a now unlocated reference photograph of the factory. Several years later, the artist reused the composition of this rather modest watercolour for his monumental oil painting, *Classic Landscape* (illus. 37). Additional industrial subjects emerged during the early 1930s, all based on surviving or now lost photographs of the Ford plant: precisely rendered conté crayon drawings, such as

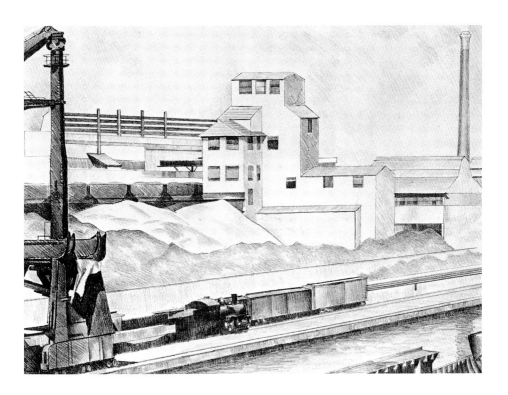

48 *Industrial Series # 1*, lithograph, 1928

Smokestacks (illus. 49) and *Ballet Mechanique* (illus. 50), executed in 1931; and two major oil paintings, *River Rouge Plant* (illus. 39) and *City Interior* (illus. 40).

These paintings and drawings of the early 1930s also received enthusiastic praise. Illustrated in *Survey* magazine, *Smokestacks* and *Ballet Mechanique* inspired Florence Kellogg to comment that the exquisitely rendered drawings are 'delicate and lovely versions of familiar things rarely associated with delicacy and loveliness. Sheeler has a harmonious acceptance of his age, a vision of its rhythm and order.'[176] Indeed, these works of 1930 to 1932, along with the earlier photographs, are Sheeler's most compelling views of American industry; not all of the images, however, are as harmoniously accepting of the age as Kellogg suggests.

Curiously, Sheeler's powerful paintings and drawings of industrial subjects date from the worst years of the Depression. During this period, the Ford Motor Company's enormous profits changed into losses of more than thirty-seven million dollars; from 1929 to 1932, the company drastically reduced its workforce and cut wages, which led to

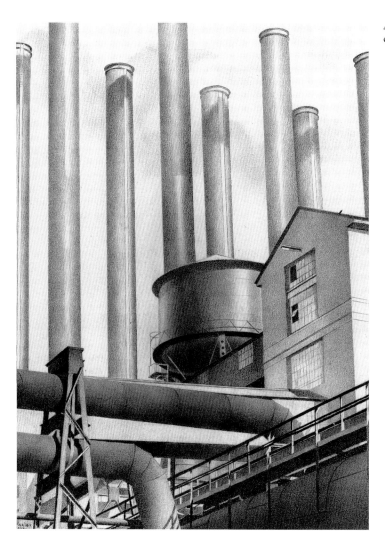

intense labour unrest.[177] During a mass hunger protest in
1932, police killed four unemployed workers outside the
Rouge plant. This incident severely tarnished the Ford Com-
pany's public image. More people began to see that industrial
practices could become not only disempowering, but deadly
as well. John Dos Passos wrote of the killings in 1933,
'. . . When the country on cracked shoes, in frayed trousers,
belts tightened over hollow bellies . . . started marching from
Detroit to Dearborn, asking for work . . . all they could think
of at Ford's was machineguns.'[178] The situation was similar,
if not worse, throughout American industry, causing many

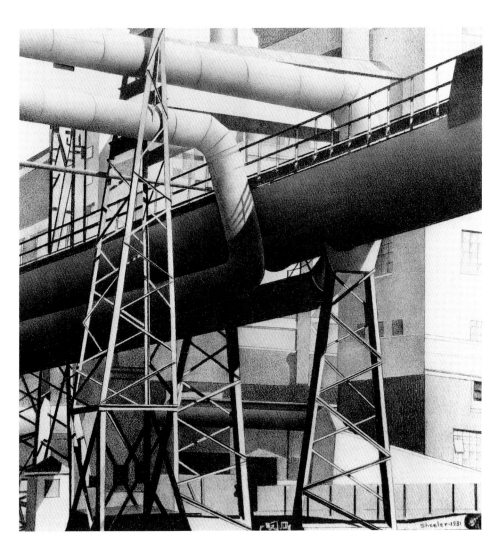

50 *Ballet Mechanique*, conté crayon, 1931

to question the principles of corporate control that Ford and other major manufacturers practised.

Why, then, did Sheeler return to these subjects at such an inauspicious moment in the history of American industry? The widespread critique of industry that followed the country's economic collapse must have deeply unnerved him on some level. After all, Sheeler had bolstered his artistic identity in part through the great prestige America enjoyed as an industrial nation, and his earlier images had traded on those powerful associations. This strategy had successfully advanced his career in the late 1920s, but in the 1930s, Amer-

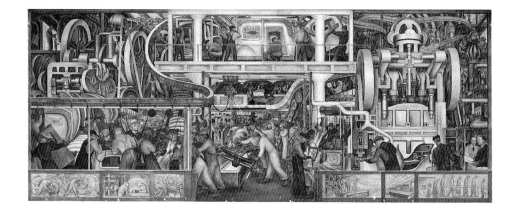

51 Diego Rivera,
*Detroit Industry,
South Wall,*
mural, 1932–33

ica's industrial prestige was rapidly waning. Returning to this subject at the onset of the Depression was perhaps Sheeler's way of trying symbolically to shore up industry's aura of omnipotence – something that his career had depended upon – even as its actual strength was crumbling. At the same time, I believe the collapse of industry brought about a real, if subtle, change in Sheeler's treatment of these subjects. It stimulated works, such as *Classic Landscape* (illus. 37), that conveyed a haunting sense of absence, much more pointedly than in the River Rouge photographs.

In contrast, socially committed artists during the Depression, such as Louis Lozowick, Diego Rivera, and Ben Shahn, introduced workers into their images of the American scene, indicating a new concern with labour's contributions to industry. One of the best examples of this shift in perspective is Rivera's monumental mural cycle done in 1932 for the Detroit Institute of Arts (illus. 51). In the early 1930s, such works introduced Americans to the revolutionary aesthetic programmes of Rivera's native Mexico, where large, public murals incited popular support for Marxist ideals. Like Sheeler, Rivera found the forms of American industry magnificently beautiful; but in his view of the River Rouge factory, workers appear in conjunction with every part of the manufacturing process. In the panel depicting the production of Ford V-8 automobile bodies, Rivera boldly portrays all the demanding routines involved in activities around the assembly line. Bracketed by huge stamping presses, men and women toil together as they weld, paint, assemble parts and operate machinery.[179]

Parallel to the Soviet Communists' admiration for the River Rouge photographs by Sheeler, Rivera's enthusiasm for industrial production in America was not stifled by its association with the capitalist exploitation of labour. But he did reveal some of the oppressive aspects of Ford's coercive architecture of production. In the Detroit mural, the labourers bent over the assembly line are entrapped in a web of intersecting cables and machine parts. The mammoth, robotic stamping press to the right, like Sheeler's earlier photograph of a similar machine (illus. 44), dominates and diminishes the workers at its base. But whereas Sheeler's photograph only hints at the machine's domination of humankind at the Ford plant, Rivera's mural expresses this relationship more overtly. On the other hand, Rivera's workers, united by their labour, appear heroic – if rigidly controlled. In contrast, the figures in Sheeler's industrial scenes are always isolated, insignificant and marginalized.

Indeed, Rivera and Sheeler's contemporaneous views of the Ford factory both address – either directly or obliquely – fundamental realities about American labour. Fuelled by revolutionary optimism about a future worker-controlled state, Rivera puts his labourers at centre-stage and pays homage to their disciplined efforts in a controlled and demanding environment. Exhibiting greater pessimism about the human place in the machine-dominated world, Sheeler's River Rouge paintings comment on the plight of workers by excluding or minimizing them; their diminished presence adumbrates a state of powerlessness in a dehumanized, technocratic environment.

American Landscape (illus. 38), even more than *Classic Landscape*, exemplifies this dark and troubling view. Unlike most of the Rouge photographs, the work depicts the Ford complex from a detached and distant viewpoint. The panoramic scene includes a boat slip and a cement plant on its shore, indicating the wide range of operations that occurred at the site.[180] The horizontal format induces calm, the water is placid and still, and a lone smokestack pours out vapours that mingle with the clouds in the sky. All activity seems momentarily arrested except for a tiny worker (barely noticeable in the middle-ground between the boxcars) who runs off alone to perform some unspecified task. Eclipsed by the overwhelming grandeur of the industrial landscape, this isolated individual disturbs the picture's veneer of serenity. As Constance Rourke

wrote of this work: 'The enduring fact is that the vast mechanism has its own life, its own conquests and future.'[181] What she did not add, but what the painting suggests to me, is that the chief conquest of Ford's complex is humanity.

The larger implications of this work indeed raise intriguing questions. Leo Marx, in *The Machine in the Garden*, addresses some of these issues when discussing *American Landscape*:

> Even those Americans who acknowledge the facts [about technology] . . . seem to cling, after their fashion, to the pastoral hope. This curious state of mind is pictured by Charles Sheeler in his 'American Landscape'. Here at first sight is an almost photographic image of our world as it is, or, rather, as we imagine it will be if we proceed without a change of direction. No trace of untouched nature remains. . . . Technological power overwhelms the solitary man; in this mechanized environment he seems forlorn and powerless. And yet, somehow, this bleak vista conveys a strangely soft, tender feeling. On closer inspection, we observe that Sheeler has eliminated all evidence of the frenzied movement and clamour we associate with the industrial scene. . . . This 'American Landscape' is the industrial landscape pastoralized. By superimposing order, peace, and harmony upon our modern chaos, Sheeler represents the anomalous blend of illusion and reality in the American consciousness.[182]

In this passage, Marx sees Sheeler's so-called pastoralism as a kind of false consciousness repressing the anxiety caused by the subject. Sheeler's work is therefore a 'popular' or 'sentimental' pastoralism, an attempt to mask the complexities of modern technological transformation with older conventions of artistic representation.[183] Marx finds the artist's presentation psychologically complex, ambiguous and multifaceted, but falsifying at its core. Sheeler has unconsciously transformed a harsh reality into something easier to take.

My reading of the painting, however, finds greater significance in the tiny figure in *American Landscape* (illus. 52). Although Marx notes the 'forlorn and powerless' worker, he underestimates the troubling implications of labour's diminished state. The serenity and grandeur of the embracing context never completely efface the thematized impotence of this lone human being. Therefore, whether Sheeler con-

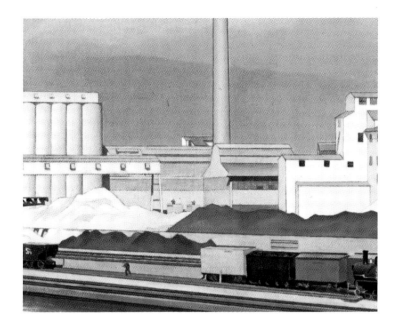

sciously or unconsciously presented this indication of the worker's powerlessness, his unsettling presence compromises the painting's ability to pacify an audience of viewers already uneasy about the dominance of industry.

William Carlos Williams, in a draft of an essay on Sheeler's work written in 1939, also attempted to explain the artist's puzzling diminishment of human presence in his industrial scenes:

> Sheeler has devoted himself mainly to . . . landscapes with little direct reference to humanity. This does not in the least make him inhuman, since when man becomes insignificant in his attributes and swollen to fill the horizon the representation of the human face is not enlightening.[184]

Here Williams does not seem to endorse the grandiose human accomplishments that swell 'to fill the horizon', such as the Ford factory complex; rather he implies that modern hubris has diminished our 'attributes' and has made people insignificant and unworthy of representation. Therefore, Sheeler's avoidance of humanity in his work is a natural outcome of debased social conditions. Williams further elaborates:

> Inhuman is a word commonly used to describe the efficiency of the modern industrial setup, as in some minds coldness

is often associated with Sheeler's work – incorrectly. Sheeler chose as he did from temperament doubtless but also from thought and a clear vision of the contemporary dilemma.[185]

In attempting to explain the apparent coldness and inhumanness in Sheeler's industrial scenes, Williams finds these qualities, not only in the artist's reticent temperament, but also in his perception of some 'contemporary dilemma'.

The nature of this dilemma remains incompletely articulated in this essay, but in 1954, Williams takes up the issue again:

> Charles Sheeler has lived in a mechanical age. To deny that was to lose your life. That, the artist early recognized. In the world which immediately surrounded him it was more apparent than anywhere else on earth. What was he to do about it? He accepted it as the source of materials for his compositions. . . .
>
> By faking the psychologic appearance of the machine . . . so that it appears to be what it is not, is no gain to painting. Neither is the ignoring of the machine's contours until it entirely disappears from our consciousness. To take the machine and make its contours acceptable to our eye by using it in our compositions is admirable in a modern artist.[186]

In these passages, Williams claims that Sheeler had directly confronted the machine-dominated world of America and had incorporated it appropriately into his art. This was obviously an important concern for the poet as well. In Williams's view, the artist's work should be based on the local and indigenous, however unaesthetic those conditions might seem to be. His poem 'Classic Scene', written in 1937, addresses the pervasive industrial ambience of the poet's own milieu in the north-east.[187]

A power-house
in the shape of
a red brick chair
90 feet high

on the seat of which
sit the figures
of two metal
stacks – aluminum

commanding an area
of squalid shacks
side by side –
from one of which

buff smoke streams while under
a grey sky
the other remains

passive today –[188]

This incorporation of American technology into the poetic realm could be considered a humanistic triumph over the machine, similar to what Rosenfeld felt Stieglitz had done with his photography. In Williams's poem, the stacks become commanding anthropomorphic figures and the powerhouse their throne. But a vaguely unsettling conflict exists in 'Classic Scene' between the unsightly shacks and the assertive power plant, between the active and passive aluminium stacks. As with Sheeler's industrial scenes, we struggle to assess this seemingly straightforward description. In the detached, objective language, an understated voice proclaims a dissonant message about a world totally dominated by industry. The realm it commands is eerie, squalid, and deathly still.

Indeed, Williams's 1954 essay on Sheeler's work interjects a surprisingly pessimistic note with regard to the industrial subject. He describes the power of *Classic Landscape* as resulting from 'a realization on the part of the artist of man's pitiful weakness and at the same time his fate in the world'.[189] Finally, we glimpse what the 'contemporary dilemma' meant to Williams. The creative individual's fate – especially in America – is to live in a mechanical age, a fact that cannot be denied. The artist must address this in his art, but in doing so, he finds that the machine remains alien and aloof; humanity is pitifully weak in its domain. Williams apparently maintained faith in the artist's ability to create vital expressions in the face of such challenges, however, because he concluded the essay with a more positive, if incongruous, thought: 'These are the themes which under cover of his art Sheeler has celebrated.'[190]

Sheeler, when asked to explain the diminished human presence in his industrial scenes, advanced yet another, possibly ironic, explanation: 'Well, it's my illustration of what a beautiful world it would be if there were no people in it.'[191]

This uneasy and self-critical sense of the human place in the machine age in part explains, I believe, the puzzling obliqueness of Sheeler's industrial scenes. The factories and conveyors remain obstinately separate from humanity; to include people would only detract from their beauty, in the artist's view. At the same time, Sheeler's presentations, unlike Stieglitz's images, offer little hope that the creative individual can triumph over the mechanistic phenomena depicted.

Yet the artist apparently did not intend to protest against industry's dominating tendencies in his work. 'I don't believe I could ever indulge in social comment,' he told the art historian Frederick Wight in 1954.[192] In fact, in this interview Sheeler yet again compared the grandeur of the American industrial environment with medieval Chartres, adding: 'Maybe industry is our great image that lights up the sky.' But in reporting Sheeler's remarks, Wight noted that the artist paused hesitantly after this grandiose statement. When Sheeler concludes with the thought, 'The thing I deplore is the absence of spiritual content',[193] neither Wight nor the reader seems to know for sure where Sheeler stands. Does industry have spiritual content for Sheeler, or does it represent the annihilation of such content?[194] Beyond their veneer of dispassionate objectivity, the images themselves resonate with this unanswered question, indicating a divided and unresolved attitude towards the subject.

Sheeler's presentation of industry and sophisticated technological artifacts became even more complicated and troubling in the late 1930s, when the cult of the machine was in its waning years. In 1938, he received an important commission from *Fortune* magazine – a glossy, illustrated business journal – to produce a series of paintings on the theme of 'Power'. Sheeler worked on the project until 1940, and ultimately painted six images. *Primitive Power* (illus. 53) depicts an outmoded but still functioning overshot waterwheel in Alabama. Like *Interior, Bucks County Barn* (illus. 11), the work reveals Sheeler's use of preindustrial artifacts to advance a nationalistic agenda; here the earliest image in the series provides a historical lineage for the country's contemporary dominance in technology. The painting suggests that Americans' practical inventiveness in the nineteenth century has led to the industrial wonders of today. In *Yankee Clipper* (illus. 58), Sheeler presents a fragmentary, close-up view of a propeller

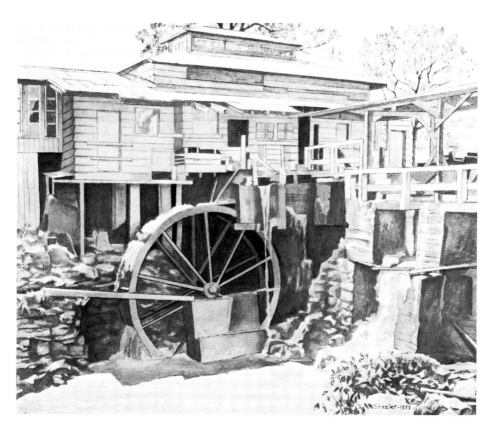

belonging to a sleek, newly designed, long-distance passenger plane. *Rolling Power* (illus. 59) is another isolated fragment of a machine, this time the crankshaft and drive wheels of a New York Central locomotive. *Suspended Power* (illus. 60) represents a massive hydraulic turbine generator hanging in mid-air, in the process of being installed by the Tennessee Valley Authority at a hydroelectric plant in Guntersville, Alabama. *Steam Turbine* (illus. 61) shows the cavernous interior of the world's largest steam power plant, recently opened in Brooklyn. In the painting, an incongruously delicate fence separates the mammoth turbine from a complicated array of pumps and valves in the foreground. *Conversation – Sky and Earth* (illus. 62) portrays a radio transmission tower silhouetted against a brilliant blue sky with the newly built, monumental Hoover Dam in the background.[195]

In the *Fortune* series, the artist expanded his machine iconography to include transportation vehicles and other artifacts of advanced industrial culture in far-flung locations through-

out the country. As in all of Sheeler's work during this period, photographic studies preceded the paintings; one such was *Wheels* (illus. 54), which closely corresponds to the painting *Rolling Power*. But Sheeler undoubtedly relied on another, now unlocated photograph, as a model for the left side of the painting's composition. Despite the fact that he had previously used photographs as models for his compositions, the *Fortune* works exhibit an unprecedented degree of photorealistic detail.

On some level, Sheeler clearly aimed to impress and astound viewers with this series; except for the preindustrial mill, he presented the most up-to-date, grandiose product in each category: the fastest aeroplane; the swiftest train; the largest steam power plant; the mightiest dam.[196] In 1940, *Fortune* published Sheeler's series in a full-colour picture essay, and the magazine's editors similarly glorified these subjects in the captions to the illustrations. They made the familiar comparison of industry to religion, claiming that 'the heavenly serenity of Sheeler's style brings out the significance of the instruments of power he here portrays'. Describing *Suspended Power*, they wrote, 'Here, in a room larger and more still than

a corridor in the Vatican, the runner of a hydroelectric turbine floats majestically down into its pit.' They, too, found a justification for the diminished human presence in these subjects, claiming that 'the modern American artist reflects life through forms such as these; forms that are more deeply human than the muscles of a torso because they trace the firm pattern of the human mind as it seeks to use co-operatively the limitless power of nature.'[197] Here *Fortune*'s editors laud the very phenomenon that Simmel, Gramsci and others identified as problematic in their analysis of industry's impact on human psychology: a reduction of experience to a disembodied rationalism; a substitution of the machine for the whole, integrated person.

Fortune naturally waxed hyperbolic about such subjects – the expensive magazine catered to a readership of powerful, high-level managers and entrepreneurs in America. Yet contemporary critics received these works far less enthusiastically than the earlier River Rouge paintings. One disgruntled writer for *Parnassus* claimed: '*Yankee Clipper* and *Rolling Power* . . . have nothing to offer beyond the colored photograph and the question may legitimately be raised as to whether these paintings are art.'[198] Sheeler's exactingly literal renderings of such grandiose subjects seemed to many reviewers excessively controlled, cold, and inexpressive. 'It is not only upon the grounds of their dependence on the camera that they are to be criticized, but on their failure to capture the nature of power. . . . Sheeler may be said to have overlooked the soul of the machine,' the *Parnassus* critic concluded.[199]

The 'Power' series is indeed an unsettling representation of its subject. Compared to Sheeler's Rouge photographs and industrial paintings of the early 1930s, these machines are simply much less attractive. In *Conversation: Sky and Earth*, for example, the antennae and wires bind the sky like an imprisoned hostage, and the craggy cliff at the lower right seems as inhospitable to human life as the moon's surface. The turbine in *Suspended Power* hovers aggressively over the tiny workers at the edge of the pit like a monstrous phallic weapon. One man even appears on the verge of being cut in half by its ominous, pincer-like blades.[200] The Brooklyn steam turbine is so massively out of scale with its environment that it appears to be a 'freakish caged beast'.[201] And the high-keyed, strident pinks and blues contrasted with dull,

metallic greys in the paintings increase their disquieting effect.

In sum, Sheeler's *Fortune* series gives evidence of increased dissonance and unease with regard to industrial and technological subjects. In the paintings, heightened anxiety emerges about the conquest of the machine over humanity. Such fears seem appropriate in an era when industry in the command of warring world powers threatened unprecedented levels of destructiveness. Indeed, the Second World War marked the end of the machine age and a shift in attitude towards subjects once idealized by American artists and the public. The myth of technological and industrial beneficence was rapidly disintegrating.

For Sheeler, these years signalled an anxious and painful re-evaluation of the premises of his art. He continued to

55 *Manchester*, oil, 1949

56 *Water*, oil, 1945

produce paintings on industrial and technological themes during the 1940s, but in response to the harsh criticism of the photorealistic detail in the *Fortune* series, he moved haltingly towards greater abstraction. *Manchester* (illus. 55), for example, conflates two views of a nineteenth-century textile mill and reduces the forms to flat, relatively undetailed planes. This kind of presentation tends to neutralize any troubling implications associated with the subject. Nevertheless, many of these transitional works, such as *Water* (illus. 56), still contain explicitly brooding, threatening elements. In this painting, done in the year when the United States was preparing to drop atom bombs on Hiroshima and Nagasaki, repetitive towers and massive pipes line up like deadly tanks prepared for battle. Most disturbingly, the towers' lookout stations lack human operators; they seem to signal an era of total global depopulation. The frightening technological monuments are the only elements left in command.

During the post-World War II era, Sheeler began to receive

criticism for his supposed role as a leading apologist for America's capitalistic exploitation of industry. This, too, indicates a fundamental shift in society towards greater scepticism regarding industry and technology. One labour sympathizer wrote in 1949:

> Sheeler approaches the industrial landscape . . . with the same sort of piety Fra Angelico used toward angels. His architecture remains pure and uncontaminated without any trace of humans or human activities, an industrialist's heaven where factories work themselves. In revealing the beauty of factory architecture, Sheeler has become the Raphael of the Fords. Who is it that will be the Giotto of the U.A.W.?[202]

Critics favourable to industry acknowledged these left-wing criticisms but dismissed them: 'Labor has always feared technology. In [Sheeler's] richly austere industrial scene, . . . the U.S. worker is missing. Labor is disturbed by such glittering geometry; its fear that the machine will put man out of work is a short-range truth, a long-range error.'[203] Commentators today still often assume that Sheeler's paintings are an unambivalent celebration of American industry. A recent reviewer of the 1987–8 Sheeler retrospective exhibition described the artist as 'an iconographer for the religion of technology', claiming that he 'depicted industry with confidence'.[204] The art historian Matthew Baigell called Sheeler 'the true artist of corporate capitalism'.[205]

No doubt paintings such as *Classic Landscape* and *American Landscape* do monumentalize the industrial forms, and the *Fortune* series does attempt to convey the power of American technology. But do these haunted, frozen images unambivalently celebrate the subjects they depict? All of these paintings efface the worker's involvement in the industrial landscape, but to what end? The elimination of labour's physical presence in Sheeler's paintings suggests, I believe, a metaphorical truth about its lack of actual power at a time when unions were still banned in many American industries.[206]

In Sheeler's industrial subjects, as in the scientifically managed workplace, labourers exert little control over manufacturing processes. Instead, the architecture of production controls or eliminates them. And the generalized titles of Sheeler's industrial paintings (*American Landscape*, for example) indicate

that this impotence extends beyond the boundaries of Ford's River Rouge plant. Both paintings and titles suggest human displacement as a general characteristic of a culture that has exploited both workers and industrial methods to the maximum.

At this juncture, it is important to recall Sheeler's concern for 'an absence of spiritual content' with regard to the industrial subject, and also Gramsci's observation that managerial imperatives attempt to root out the spiritual dimension of production in the workplace. Although, to my knowledge, Sheeler never commented on the working conditions in Ford's factories, he was himself, in fact, once a cog in Ford's machine. In February 1929, he was still working for Ford, now photographing a new line of Lincoln Continentals for advertising purposes. During this time, he reflected deeply on the psychological costs involved in his continued employment at the company. Sheeler's commission to photograph these expensive vehicles bored him intensely at this point. This commercial work kept him from more satisfying, self-generated art. Nevertheless, the job enabled him to purchase one of the luxurious automobiles for himself, and he gained inordinate pleasure from the beautifully crafted vehicle. As he wrote to Walter Arensberg:

> Believe me when I tell you that to sit at the wheel is a revelation. It is to begin over again. The feel and the sound of the engine is something to wake up in the middle of the night and think about. My pleasure in it is akin to my pleasure in Bach or Greco and for the same reason – the parts work together so beautifully.[207]

His exuberant prose is not unlike the advertising copy written to sell these cars, which promised 'power in abundance, more speed than you may ever use, swift acceleration, effortless control, wonderful riding luxury and comfort, beautiful and distinguished appearance'.[208] But Sheeler also admitted to Arensberg the limits of his compensatory pleasure in the product he was photographing. Owning the car, he wrote, was a way of making something happen from the outside as a 'poor substitute for something from the inside'.[209]

Sheeler's comments reveal a conflict central to our consideration of the machine age in America. He idealized Ford's Lincoln Continentals, but he also hated doing the repetitive

work of promoting them, just as an assembly-line worker might have loved owning a Model A while despising the labour involved in producing them. Although Sheeler's status as a freelance photographer afforded him much more autonomy than a factory labourer, both the artist and Ford's workers were similarly trapped in the American system of dehumanized production and compensatory consumption.

When Ford encountered resistance to dehumanizing industrial practices in 1913, he appeased his alienated workers by granting them greater spending power, contributing to the general shift away from production towards consumption as a source of satisfaction. During the 1920s, car ownership was a particularly important component in this shift, because 'motoring acted as a therapy which adjusted individuals to the strains of modern life by giving a sense of release while tying the people concerned more tightly to the existing order'.[210] Van Wyck Brooks recognized as early as 1918 that it was in management's interest to encourage workers 'to seek reality in anything else than their work – riding about the country in Ford cars, on Sundays, for example, with their mouths open'.[211]

Compensatory consumerism may indeed mask a great deal of discontent, but there are limits to its obfuscating power. Sheeler's letter to Arensberg reveals a painful awareness of those limits. Car ownership gave him the sensation of a fresh start, but at the same time, he recognized that this consumerist pleasure was a hollow substitute for genuine engagement in work.

Within this context, the lonely worker in *American Landscape* can be re-examined as a surrogate artist-figure, as a kind of displaced self-portrait. Seen in this light, the painting seems to echo a passage written by the poet Sherwood Anderson in 1927:

> Man's inheritance – his primary inheritance – is being taken from him perhaps by mass production, by the great factory, by inventions, by the machine. . . .
> It may be that the age of the individual has passed or is passing. . . . When the workman, the workman impulse, passes there will be no more artists.[212]

Indeed, Sheeler's paintings of industry and technology subtly articulate a similar message about the imminent eclipse of

individual creative expression. The ideology of the moment encouraged glorious visions of the machine age, but Sheeler's art also suggests that the price of industry's triumph is the demise of the painter's role as artisanal 'demiurge'. No wonder the paintings exude a haunting sense of absence.

Yet in spite of these ambivalent factors, or perhaps *because* of them, Sheeler's industrial paintings of the early 1930s possess an undeniable power. Strikingly compelling to contemporaries when first created, they continue to fascinate us today. They speak to us in ways that are not easily analysed – touching on our needs to idealize as well as our fears of being annihilated by the object of our regard. Bringing conflicting hopes and anxieties to the surface, albeit subtly, they not only express ideology but also enact its own virtual unmasking and self-criticism.[213] While such works relate to the hyperbolic rhetoric about industry during this era, they also turn the rhetoric in on itself to reveal its hollow core. This subtle unmasking – Sheeler's concretization of dialectical tensions inherent in the subject – contributes to the haunting quality of *Classic Landscape, American Landscape*, and all of the artist's best works from the early 1930s.

Machine-Age Interiors

Sheeler's most profound and disturbing reflections on the machine age emerge in the artist's depictions of interiors. Works such as *View of New York* (illus. 63), *Home Sweet Home* (illus. 64), and *Self-Portrait* (illus. 67) demonstrate the intrusion of technologically sophisticated artifacts into intimate, domestic life. Even more than in his images of skyscrapers and factories, these works investigate notions of personal identity in the machine age. They address its challenge to both the traditional aims of artistic production and to notions of the creative self's autonomy.

Depictions of machine components and consumer products were well-established in American painting by the time Sheeler executed these works. Although Sheeler's images share features in common with other treatments of machine subjects – especially in the precise, hard-edged rendering of the objects – his are distinctive in important respects. One idiosyncratic quality is Sheeler's contextualization of the machine. Technologically sophisticated instruments – a telephone, camera equipment, and a streamlined gas furnace – appear in studios and domestic settings, in fact, in the depictions of the homes and apartments that the artist inhabited in New York and South Salem during the 1920s and 1930s. Other American artists tended to approach the machine more abstractly, by presenting views of it in a more decontextualized manner.

Morton Schamberg, as we have seen in *Mechanical Abstraction* (illus. 8), helped establish this norm by suspending his machines in unspecific settings. Paul Strand's photographs are similar in this regard. *Double Akeley* (illus. 57), for example, depicts the inner workings of the motion picture camera that Strand owned. Like Schamberg, Strand focuses solely on the machine itself, but instead of placing it in an empty field, he shows a fragmentary, close-up view of its parts. Both painter and photographer emphasize the machines' formal properties above all else, accentuating their assertive geometries, sleek surfaces, and linear clarity.

57 Paul Strand,
Double Akeley,
photograph,
1922

Strand's *Double Akeley*, viewed in isolation, suggests an unambivalent celebration of the machine. The photographer's writings tell a different story, however. In an essay published in 1922, 'Photography and the New God', Strand examined the impact of advanced technology – and the modern world-view that gave rise to it – on traditional modes of production. He began the essay by constructing an ironic creation myth about the modern industrial era, which recalls Rosenfeld's similarly satirical formulation:

> Man having created the concept of God the Creator, found himself unsatisfied. . . . For when it became apparent that craftsmanship as a means to trade growth was insufficient, that quantity and not quality of production was the essential problem in the acquisition of wealth, it was the scientist

and his interpreter the inventor who jumped into the breach. . . . [He therefore] consummated a new creative act, a new Trinity: God the Machine, Materialistic Empiricism the Son, and Science the Holy Ghost.[214]

Strand felt that in rationalized and materialistic industrial culture, society regards all quality craftsmanship and artistic endeavour with indifference or contempt. Nevertheless, like Rosenfeld, he asserted that creative photographers (such as Stieglitz and himself) were combating these attitudes by using their picture-making machines for 'the single purpose of expression'.[215]

Thus the deeper significance of a machine, the camera, has emerged here in America, the supreme altar of the new God. If this be ironical it may also be meaningful. For despite our seeming wellbeing we are, perhaps more than any other people, being ground under the heel of the new God, destroyed by it. . . . We have it with us and upon us with a vengeance, and we will have to do something about it eventually. Not only the new God but the whole Trinity must be humanized lest it in turn dehumanize us.[216]

Such passages articulated the urgency of Strand's mission to humanize the machine.

As an antidote to the materialism of the machine age, Strand advocated re-establishing the artist's traditional humanistic prerogative to create unique and personal expressions. *Double Akeley*, in its unusual framing and daringly abstract composition, indeed asserts Strand's personal creativity. But the image's cool formalism gives little evidence of the philosophical and aesthetic battle that the photographer was waging in his art. Removed from the context of his essay, the photograph alone fails to convey the complex aspects of Strand's ambitions.

Strand and Schamberg were especially close to Sheeler during the formative period in his career, and their works undoubtedly stimulated his interest in machine subjects. Like them, Sheeler rarely pictured people in association with the mechanized environment. But oddly enough, considering his treatments of other related subjects, he personalized the settings for these machines, thereby thematizing the impact of technology on human existence more directly than in Strand's

58 *Yankee Clipper*, oil, 1939
59 *Rolling Power*, oil, 1939

60 *Suspended Power*, oil, 1939

61 *Steam Turbine*, oil, 1939

62 *Conversation – Sky and Earth*, oil, 1940

63 *View of New York*, oil, 1931

64 *Home Sweet Home*, oil, 1931

65 *Cactus*, oil, 1931

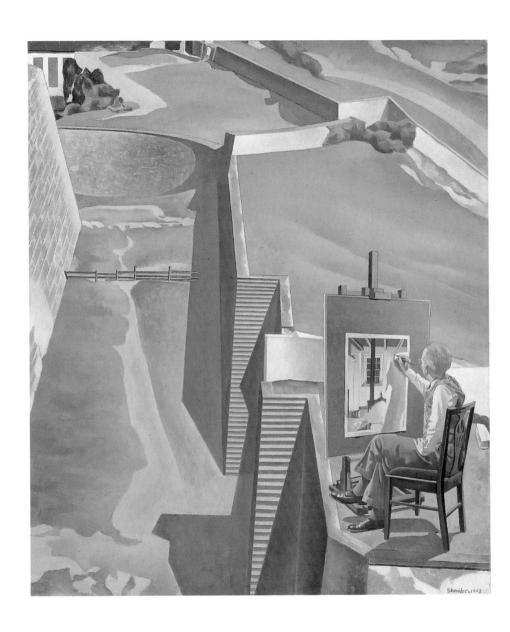

66 *The Artist Looks at Nature*, oil, 1943

photographs or Schamberg's paintings. At the same time, Sheeler's works express little confidence that the artist can reassert his creative prerogatives in the midst of a mechanized existence. Therefore, Sheeler's machines unnerve us in ways that Strand and Schamberg's images never do.

This appears most strikingly in Sheeler's *View of New York* (illus. 63). Painted in 1931, the work represents Sheeler's photography studio in the Beaux Arts Apartment Hotel on East Forty-fourth Street.[217] In a shallow, stark interior, we see an open casement window revealing a pleasant blue sky and pinkish, billowy clouds. The window is simultaneously a represented object and a self-referential device, forming a frame that mirrors the shape of the canvas on which the work is painted. Its linear, grid-like pattern dominates the organization of the composition; only a few diagonal lines point away from it. This grid reinforces our sense of the flat plane on which the picture is painted, and despite the realism of Sheeler's style, the underlying geometric structure asserts a modernist foundation for his art.

In front of the window's flat, linear scaffolding, the objects in the room have a fuller, more volumetric presence. A black photographer's lamp hovers at upper left. Part of a small metal-and-canvas chair, representing a design by the Danish craftsman Kaare Klint, appears below.[218] The presence of the chair, considered daringly vanguard in its day, attests to Sheeler's awareness of international trends in functionalist design. To the right is a tall stand with hand cranks for raising and lowering a camera – probably the large 8 x 10-view camera Sheeler used in his commercial practice. We do not see the camera itself, however, because a black photographer's cloth covers it.

Like New York itself, the objects in the painting exhibit a sense of glamorous modernity. Sheeler's technique accentuates this quality; the sleek, smooth paint surface suggests the precision of modern machine manufacture rather than the irregularities and personal touches arising from traditional handcraft production. In fact, the urban setting, the functionalist furniture, the picture-making machine dominating the centre of the canvas, all rendered in Sheeler's impersonal style, might in the abstract add up to a resounding affirmation of art-making based on principles of mechanical reproduction.

On further consideration, however, the painting invokes

more brooding and troubled thoughts. Sheeler's camera is ominously shrouded and inoperable under its cover. This animates the object with a mysterious, almost threatening, presence. In addition, the viewer's position is near ground level. In fact, we see the underside of the camera stand from this angle. Therefore, we are forced to look up submissively at the camera while it glowers over us. Also, the lamp is turned off, and the chair is shoved away from the viewer. Although all these objects imply human presence, no one could use them at the moment. Here Sheeler carefully sketches out a human context, only – it seems – in order to make it troubling and problematic.

Another perplexing feature of the work is its lack of topographical specificity. The painting's title supposedly offers a 'view of New York', but where are the skyscrapers and other landmarks that would allow us to identify it as such? If we could enter the picture in search of the promised view, we would need to move closer to the window and look down in order to see any feature that might qualify as unique to New York. But the camera keeps us at bay, limiting us to a glimpse of a generic sky that could be anywhere at all.

Equally unsettling is the structure of the casement window. The top transom recedes into space, indicating that the window is open. But the bottom transom lies parallel to the sill, revealing that the window is closed. Therefore, a fundamental contradiction exists in the window's structure. How could it be open and closed at the same time? Such a contradiction, like the absent view, grows more unsettling as we continue to look at the work and ponder its implications.

After the Boston Museum of Fine Arts bought *View of New York* in 1935, a staff member asked Sheeler for some explanation of this mysterious painting. The artist replied politely but elusively, 'I wish I could give you an interesting story in connection with *View of New York*, but alas it would have to be drawn from imagination and I am a realist. It was painted in 1931 in a studio which I had at that time in New York. So you see the title really is authentic.'[219] Sheeler's evasive letter did not explain any of the obvious incongruities in the work, and his claim to be a realist contradicts the painting's defiance of our attempts to understand its logic. Sheeler's statement quoted in Rourke's biography is truer to the work's unsettling mood: 'I know that "View of New York"

may be called a cold picture, it is very uncompromising; some might call it inhuman. It is the most severe picture I ever painted.'[220]

The picture's severity results not only from its stark forms and austere design, but also from the 'inhuman' implications that Sheeler mentions. This inhumanity rests, I believe, in the painting's denial of our habitual assumption that human perception and creativity are central to existence. In place of a human centre, the camera dominates – disrupting access to the view and aggressively imposing itself on our experience of the painting. It represents a mechanized means of viewing (the world seen through a technological instrument rather than the unaided eye) and a vehicle of production removed from bodily engagement (mechanically assisted image-making as opposed to the more traditional handcraft of painting). In place of humanistic values associated with artistic perception and production – in Gramsci's sense, the artisan as demiurge – the machine is a chillingly depersonalized substitute.

Similar substitutions characterize Sheeler's work from his early maturity as an artist to the end of his career. In a photograph of his Bucks County house, *Interior with Stove* (illus. 10), a more technologically advanced, nineteenth-century stove has replaced the antiquated eighteenth-century hearth at the left. A displacement also occurs in a representation of Sheeler's South Salem residence, *Home Sweet Home* (illus. 64). As in *Americana* (illus. 35), the cosy room is filled with handcrafted Shaker objects and other antiques, but a modern streamlined furnace to the right displaces the boarded-up fireplace behind it.[221] Another particularly intriguing substitution exists in *Self-Portrait* (illus. 67), in which a machine replaces the artist himself. This witty image is the closest in the artist's *oeuvre* to a Dadaist mechanomorph. As in *View of New York*, the room represents Sheeler's own studio, presumably the one he occupied on West 147th Street at the time he made the drawing. A telephone, displaying Sheeler's own number, rests on a table-top in a shallow interior space.[222] Behind is a window peculiarly bisected by a black shade. A white cord attached to the shade loops to the left. In the dark pane of glass appears a shadowy self-portrait of the artist at his easel.

Appearing only from neck to waist, Sheeler's ghostly image often escapes the viewer's attention because the assertive

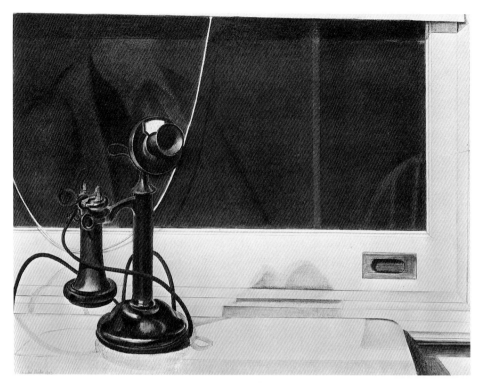

telephone diverts interest from the playfully perverse self-portrait. The artist seems to revel in the fact that the machine has relegated him to the status of a faint reflection. More troubling is the implication that the window shade has decapitated him. The shade also indicates a further threat because, by simply pulling it down to the window-ledge, even this intangible trace of artistic presence would completely disappear. Then the machine's backdrop would be a total void. Dominating the foreground, the telephone would operate itself without human assistance, completely replacing the artist as controller of the scene.[223]

In every work mentioned above, the dominant object is a technologically sophisticated instrument that replaces something with more traditional, anthropomorphic associations. In *Self-Portrait* and *View of New York*, the substitutions also involve replacing organic channels of sensation with mechanical ones. The telephone and the camera convey sound and sight through wires and lenses. These mechanical instruments – vehicles of perception and expression – recall Haviland's formulation, 'the phonograph is the image of his voice; the

67 *Self-Portrait*, conté crayon, gouache and pencil, 1923

camera the image of his eye'. But here the technological substitutions threaten to eclipse the unaided human senses, in essence the artist himself, who works laboriously by hand, using traditional media of representation: oil on canvas or pencil on paper.

An embedded theme in *View of New York* is therefore the relationship of photographic reproduction to the craft of painting. This reflects Sheeler's complicated amalgamation of these two media throughout his career. Commercial photography supported Sheeler's painting practice from the beginning of the 1910s. Initially, he sought to keep separate these two endeavours. He soon began producing 'creative' photographs, however, and exhibited his work in that medium on an equal footing with his paintings and drawings throughout the 1920s and 1930s. In addition, he began basing paintings and drawings on his photographic work. For example, *Skyscrapers* (illus. 32) of 1922 relies on the composition of his photograph *Park Row Building* (illus. 20) taken two years earlier. Sheeler simultaneously continued to produce commercial photographs as a source of income (often, as we have seen, with a great deal of resentment) up until the time he represented his camera in *View of New York*.

Two other works done in 1931, *Tulips* (illus. 68) and *Cactus* (illus. 65), include camera equipment and emphasize Sheeler's photographic practice in his New York studio. Interestingly, these three works emerged at the precise moment when the artist was finally able to renounce photography as a means of financial support. The Downtown Gallery began to exhibit his work in 1931, and within a year, his dealer Edith Halpert had marketed his paintings so successfully that Sheeler was able to give up commercial photography, vacate his New York apartment, and devote all his time to painting in his new home in Ridgefield, Connecticut.[224] This was an extraordinary situation, considering that 1932 was the worst year of the Depression. But in spite of the financial deprivation surrounding him, Sheeler faced a future free of commercial work for the first time when he painted *View of New York*. Yet the work's sombre, questioning mood may reflect the artist's ambivalence and uncertainty about this new direction in his career.[225]

As his economic dependence on photography lessened, Sheeler maintained and even intensified the relationship be-

tween it and his painting practice. By the 1930s, a photo-
graphic study preceded virtually every composition for a
painting. This dependency on photographic studies culmi-
nated in the hyperrealism of the 'Power' series for *Fortune*
magazine. According to William Carlos Williams, Sheeler even
revived the technique of the camera obscura.[226] By this, Willi-
ams undoubtedly meant that Sheeler projected photographic
images on to the painting surface as a guide to pictorial
composition.[227]

Initially, Sheeler made no effort to hide the fact that his
photographs and paintings were vitally interrelated. Through-
out the 1920s and 1930s, his exhibitions often included photo-

graphs relating to his paintings. Sheeler did feel that essential differences existed between his practices in the different media, however. He claimed, 'Photography is nature seen from the eyes outward, painting from the eyes inward. No matter how objective a painter's work may seem to be, he draws upon a store of images upon which his mind has worked. Photography records inalterably the single image, while painting records a plurality of images willfully directed by the artist.'[228]

This explanation did little to placate critics hostile to his hyperrealist style of the late 1930s. One found Sheeler's statement 'so ridiculous it's pathetic. It's to eliminate almost entirely . . . the human element, the mind and the heart of the artist which make him see the world through . . . his own experience . . . and so enable us to derive more enjoyment and meaning from it.'[229] In sum, Sheeler's paintings lost their status as unique and original creations in the eyes of unsympathetic critics because they were too closely associated with mechanical reproduction. The intensity of this animosity indicates that Sheeler's amalgamation of painting and photography challenged his audience's very definition of art as an expression of an autonomous, creative individual. Why, then, did Sheeler pursue this dangerous strategy of openly establishing an equivalence between his paintings and photographs?

Susan Fillin-Yeh has suggested that Sheeler emphasized the photographic basis of his paintings in order to establish the artist's role as an impersonal, mechanical instrument. By creating such a persona, Sheeler expressed his allegiance to machine-age values, in her view.[230] Indeed, the artistic vanguard during this period often used photography to challenge the élitist, individualistic implications of traditional painting practice. A few purists, such as the Russian Constructivist Alexander Rodchenko, completely renounced painting for photography. In an atmosphere of political utopianism, photography, with its capabilities of infinite reproducibility, seemed a better vehicle for creating art in a democratically conceived society.

So, too, believed Walter Benjamin who wrote in the late 1930s, 'that which withers in the age of mechanical reproduction is the aura of the work of art. . . . The technique of reproduction detaches the reproduced object from the do-

main of tradition. By making many reproductions it substitutes a plurality of copies for a unique existence.'[231] By 'aura', Benjamin meant the traditional art object's 'presence in time and space, its unique existence at the place where it happens to be'.[232] An artwork's magical presence derives from the fact that it is a singular creation; like a cult object, it is only available for private contemplation in a specific setting. A photograph exists in a different realm. The photographic process allows for a virtually unlimited number of cheap, identical replications of an image. This reproducibility erodes qualities of originality, uniqueness, and magical presence, but the photograph's accessibility makes it a highly appropriate art form for mass consumption in newspapers and magazines. 'Painting,' as Benjamin recognized, 'simply is in no position to present an object for simultaneous collective experience'[233]

On one level, Sheeler's works like *View of New York*, the 'Power' series, and his other photo-dependent paintings thematize the revolutionary significance of mechanical reproduction in a way that runs parallel to Benjamin's theories. In such works, the reliance on photography ultimately challenges the creator's self-concept as an autonomous maker of unique, irreproducible artifacts. Sheeler once summed this up with a mechanistic metaphor: 'No one can hope to achieve a detached identity. We are [comparable to] the parts of electrical equipment designed to carry the current on.'[234] The artist's painting technique, which resulted in impersonal, smooth surfaces devoid of brushstrokes, also effaces his role as maker of original, handcrafted objects.

On another level, however, these paintings seem far removed from Benjamin's analysis of image-making's relationship to social values. Sheeler never abandoned painting for photography, even though his works acknowledged mechanical reproduction as the emerging force of the machine age. And these paintings explore most profoundly the impact of the machine on individual consciousness rather than addressing its implications for social transformation. Retaining their aura, the works still present themselves for the viewer's solitary contemplation, although what they offer for consideration is ultimately an end to our privileged position in the world we view.

Indeed, as the camera confronts us aggressively in *View of*

New York, it establishes our vulnerability to its presence. If the cover were lifted, *we* in fact would be the object of viewing, not the fictional vista offered through the window. The painting transforms us into viewers who cannot master the view, faced with a machine that exists for itself rather than for us – a machine that turns us into an object of its superior representational power.

Such investigations into the implications of mechanical reproduction seem to have opened up a kind of abyss for Sheeler, causing him to portray cameras without operators, windows without views, and self-portraits depicting endangered or absent beings. This anxiety permeates *The Artist Looks at Nature* (illus. 66), a work that dramatically sums up Sheeler's reflections on art-making in the machine age. The painting, done in 1943, presents Sheeler sitting at his easel, turning his back to the viewer and facing a contemporary landscape of walled-in lawns. A perilous drop exists inexplicably at the left. Dangerously close to the edge of this precipice, the artist seems unaware of the environment's threat to his well-being. Indeed, instead of portraying the world surrounding him, he recreates on the paper before him an image of the Bucks County house that he lived in twenty years earlier. On the easel is a conté crayon drawing, *Interior with Stove* (illus. 69), done in 1932. A photographic self-portrait showing the artist at work on this drawing (see frontispiece) provided the model for Sheeler's representation of himself in this work. But the painting's visual references go even further back in time to a 1917 photograph (illus. 10), on which Sheeler based the 1932 drawing of the house.

Contrary to the painting's title, the artist is not looking at nature at all. 'Nature' has become a self-enclosed interior realm, in which Sheeler regresses to earlier times through a chain of images that originate in a photograph. These pre-existing pictures are unrelated to Sheeler's immediate surroundings; the 'reality' depicted on the easel was already present as an image in the artist's mind before he began the work. The artist therefore acts as if he himself were a picture-making machine, doomed to repetitive, mechanical reproduction of an already constituted reality. Having internalized technological processes, he becomes a kind of one-person assembly line for the compulsory replication of images. Such a portrayal of the artist's role articulates an existential

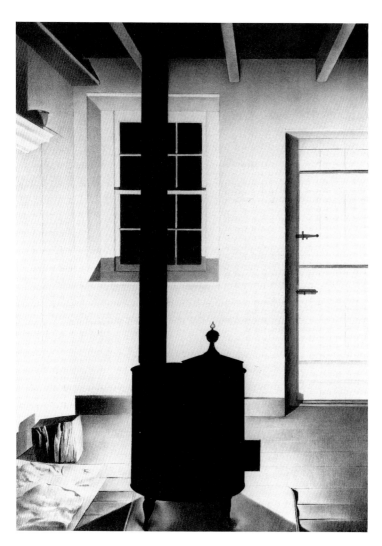

fear concerning the creative self's place in the world. As Craig Owens has written, 'If reality itself appears to be already constituted as an image, then the hierarchy of object and representation – the first being the source of the authority and prestige of the second – is collapsed. . . . The result is an overwhelming experience of absence: the abyss.'[235]

Such a view of the artist's reliance on already constituted images characterizes the discourse surrounding art-making in our own time, but the machine age ushered in an initial investigation of its implications. This realization, however, has not always appeared as alarmingly as it does in Sheeler's

The Artist Looks at Nature. Critical voices in both the past and the present have charged that humanist concepts of autonomy, uniqueness and originality in art are élitist; to view them as central to existence is a hubristic illusion. The loss of the artist's so-called human prerogatives in the age of the machine can be seen as part of a revolutionary process, as a positive step towards formulating more appropriate artistic expressions in a progressive, democratic society.

Technology's challenge to notions of human centrality has no doubt inspired various healthy re-examinations of our place in the world. Unfortunately, it has not, to date, resulted in an overwhelming rise in social justice nor in the dominance of more democratically conceived creative practices. Superstar artists still occupy a privileged realm of wealth and fame, while the public more than ever gains satisfaction from consumption rather than production.

Sheeler's public statements and his use of photography suggest a conscious relinquishment of the painter's traditional humanistic privileges. This position no doubt accorded with his self-conception as iconographer of the machine age. Nevertheless, his art reveals deep ambivalence, I believe, about the machine's challenges to his role as creator of unique artifacts. In his beautifully crafted and masterfully composed images of a machine-dominated world, in his immersion in the increasingly mechanistic aspects of image-making, he seems to mourn the death of the creative self's autonomy in a mood of anxious melancholy.

* * *

In 1946 and 1948, Sheeler served as artist-in-residence at two New England institutions, the Addison Gallery of American Art at the Phillips Academy in Andover, Massachusetts, and the Currier Gallery of Art in Manchester, New Hampshire. While at Manchester, he discovered the industrial buildings of the Amoskeag Manufacturing Company, which was the late nineteenth-century equivalent to the Ford Motor Company in the early twentieth century. In its heyday, Amoskeag was the largest textile mill in the world, employing over 17,000 workers and encompassing more than thirty buildings that lined the Merrimack River for almost a mile. But after a long period of decline, the company went bankrupt in 1936, and at the

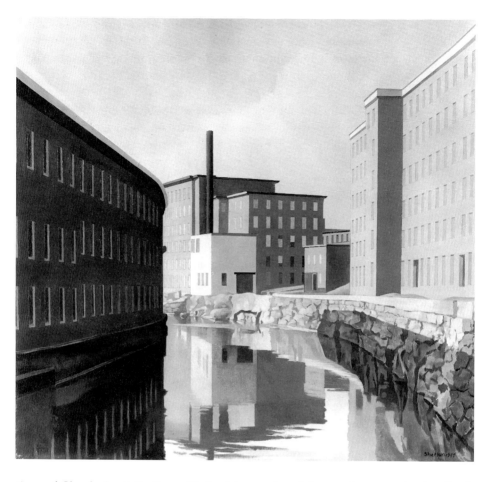

70 *Amoskeag Canal*, oil, 1948

time of Sheeler's visit, the mills had been closed for twelve years.[236]

Although Sheeler later described his time in Manchester as depressing and called the factories 'gruesome',[237] he nevertheless depicted them in several paintings, such as *Manchester* (illus. 55) and *Amoskeag Canal* (illus. 70). As with the River Rouge works of the early 1930s, Sheeler engaged this industrial subject at an inauspicious time – in this case, in an era after the company's total demise. And the more realistically rendered images in this series are similarly oblique and puzzling, as were the earlier paintings of the Ford factory. *Amoskeag Canal*, for example, is eerily placid and hauntingly still; the buildings seem suspended in a timeless realm beyond the forces of transformation and decay. Perhaps this work represents another of Sheeler's attempts to shore up symbol-

ically industry's aura of power, even in the face of its actual eclipse. And yet it, too, like Sheeler's River Rouge paintings, exudes a sense of haunting loneliness and abandonment.

Sheeler's encounter with post-industrial decay at Manchester prefigures historical developments that affect our understanding of the artist's earlier River Rouge scenes. The American automobile industry recovered after the Depression and even rose to new heights. But today plants are currently closing by the score in Michigan, once the mightiest manufacturing centre in the world. Tens of thousands of automotive workers are now unemployed, their unions seem powerless to protect their jobs, and they watch helplessly as their once burgeoning communities turn into virtual ghost towns. Dehumanizing managerial practices remain essentially intact, however, and even as American industry declines, its exploitation of advanced technology has resulted in chemical wastes, massive oil spills, vanishing rain forests, and a shrinking ozone layer. These industrial by-products threaten our very existence on the planet.

At the height of the machine age's productive power, Sheeler's factories were already deathly still and chillingly vacant. This was an observable phenomenon that few in his audience of the 1920s and 1930s found worthy of comment. Instead, they interpreted the compelling aesthetic character of the works as demonstrating the artist's conviction in the beauty and power of the machine. Indeed, this is an important dimension in Sheeler's machine-age iconography. But some contemporaries explored additional levels of meaning, such as William Carlos Williams, who found the deepest significance of *Classic Landscape* to be the artist's realization of 'man's pitiful weakness and at the same time his fate in the world'. This passage suggests that Sheeler's images provide something more than mere aesthetic legitimization of industry's dominance in the machine age; rather, his works articulate the limits of the era's ideology, albeit subtly. Today, as the infrastructure of American industry crumbles into decay, this aspect of Sheeler's machine-age iconography presses upon us more urgently. Viewing Sheeler's factories in the present moment compels us to feel the full impact of their abandonment.

References

1 See Ch. 2, 'Machine Aesthetics', in Richard Guy Wilson, Dianne H. Pilgrim, and Dickran Tashjian, *The Machine Age in America: 1918–1941* (New York: Brooklyn Museum in association with Harry N. Abrams, 1986), pp. 43–63.

2 Meyer Schapiro, 'Nature of Abstract Art', *Marxist Quarterly* (January–March 1937); reprinted in *Modern Art: 19th and 20th Centuries* (New York: George Braziller, 1978), pp. 206–7.

3 Quoted in Steven A. Mansbach, *Visions of Totality: Lázló Moholy-Nagy, Theo Van Doesburg, and El Lissitzky* (Ann Arbor, Mich.: UMI Press, 1979), p. 30.

4 Attempts to define this mode of painting are fundamentally problematic and highly controversial; therefore, I avoid the terms 'Precisionist' and 'Cubist-Realist' in my discussion. In my view, the phrase 'American variant of the machine aesthetic' more accurately denotes the style and context of such art. See Milton Brown, 'Cubist-Realism: An American Style', *Marsyas* 3 (1943/45), pp. 138–60; Martin Friedman, *The Precisionist View in American Art* (Minneapolis: Walker Art Center, 1960); Karen Tsujimoto, *Images of America: Precisionist Painting and Modern Photography* (San Francisco: San Francisco Museum of Modern Art, 1982); and Patrick L. Stewart, 'Charles Sheeler, William Carlos Williams, and Precisionism: A Redefinition', *Arts Magazine* 58 (November 1983), pp. 100–114.

5 When Sheeler produced this work, the River Rouge plant was recently completed and much heralded as the most advanced technological complex in the world. See Mary Jane Jacob and Linda Downs, *The Rouge: The Image of Industry in the Art of Charles Sheeler and Diego Rivera* (Detroit: Detroit Institute of Arts, 1978).

6 Quoted in Constance Rourke, *Charles Sheeler: Artist in the American Tradition* (New York: Harcourt, Brace & Co., 1938), p. 130. A similar formulation appears in the artist's autobiographical notes of 1937, which Sheeler turned over to Rourke when she began writing the biography. But Rourke alters his statement subtly, making the artist's position seem more celebratory. The original text is less sweeping: 'Since industry predominantly concerns the greatest numbers, finding an expression for it concerns the artist.' Charles Sheeler, autobiographical notes, Charles Sheeler Papers, Archives of American Art, Smithsonian Institution (hereafter AAA), Roll NSh1, Frame 101. Surprisingly, the artist has little else to say about industry in this source.

7 Henry McBride, 'Charles Sheeler', *New York Sun*, 13 April 1946, reprinted in *The Flow of Art: Essays and Criticisms of Henry McBride*, ed. Daniel Catton Rich (New York: Atheneum Publishers, 1975), p. 407.

8 Not until quite recently, and especially in the work of Carol Troyen and Erica E. Hirshler, has a more well-rounded portrait of Sheeler finally emerged – one that reveals the artist's works as dynamically interrelated to the beliefs of his era and yet questioning them as well. See the authors' *Charles Sheeler: Paintings and Drawings* (Boston: Museum of Fine Arts, 1987).

9 Siegfried Giedion, *Mechanization Takes Command* (London: Oxford University Press, 1948; reprint, New York: W. W. Norton, 1969), p. 2.

10 Quoted in William E. Leuchtenburg, *The Perils of Prosperity* (Chicago: University of Chicago Press, 1958), p. 188.

11 Paul Rosenfeld, 'Stieglitz', *The Dial* 70 (April 1921), p. 402.

12 Winfried Nerdinger, *Walter Gropius* (Berlin: G. Mann Verlag, 1985), p. 14.

13 See Mary McLeod, '"Architecture or Revolution": Taylorism, Technocracy, and Social Change', *Art Journal* 43 (Summer 1983), pp. 133–4; Nerdinger, *Walter Gropius*, pp. 11–12.

14 Stephen Meyer, *The Five Dollar Day: Labor Management and Social Control in the Ford Motor Company, 1908–1921* (Albany: State University of New York Press, 1981), p. 22.

15 Rosenfeld, 'Stieglitz', p. 402.

16 Antonio Gramsci, 'Americanism and Fordism', in *Selections from the Prison Notebooks of Antonio Gramsci*, ed. and trans. Quintin Hoare and Geoffrey Nowell Smith (New York: International Publishers, 1971), p. 302.

17 Peter Ling, *America and the Automobile: Technology, Reform and Social Change* (New York: Manchester University Press, 1990), p. 171; Meyer, *Five Dollar Day*, pp. 9–10.

18 Leuchtenburg, *Perils of Prosperity*, p. 186. The entire national output of England during 1926 was only about 200,000 vehicles. Lawrence H. Seltzer, *A Financial History of the American Automobile Industry* (Boston: Houghton Mifflin, 1928; reprinted Clifton, NJ: Augustus M. Kelley, 1973), pp. 57, 71.

19 McLeod, '"Architecture or Revolution"', p. 135.

20 Henry Ford, 'My Philosophy of Industry', *The Forum* 79 (April 1928), p. 487.

21 Meyer, *Five Dollar Day*, pp. 32–6.

22 Ling, *America and the Automobile*, p. 127.

23 Meyer, *Five Dollar Day*, pp. 11–23, 35–6.

24 Anonymous letter to *Ford Worker* 1 (1926), p. 3, quoted in *ibid.*, pp. 40–41.

25 Ling, *America and the Automobile*, p. 147.

26 Gramsci, 'Americanism and Fordism', p. 279; see also Meyer, *Five Dollar Day*, pp. 96–121.

27 Ling, *America and the Automobile*, p. 159.

28 *Ibid.*, p. 101.

29 *Ibid.*, p. 10.

30 Quoted in Robert Lynd and Helen Lynd, *Middletown: A Study in Modern American Culture* (New York: Harcourt Brace & Co., 1929), p. 254, n. 6; and in Ling, *America and the Automobile*, p. 122.

31 Matthew Josephson, 'Henry Ford', *Broom* 5 (October 1923), p. 142.

32 Ling, *America and the Automobile*, p. 126.

33 Leuchtenburg, *Perils of Prosperity*, pp. 178–81.

34 Wilson and others, *The Machine Age in America*, pp. 25–6; Jeffrey L. Meikle, *Twentieth Century Limited: Industrial Design in America, 1925–1939* (Philadelphia: Temple University Press, 1979), p. 8.

35 Americans continued to be fascinated with machines and technology, but the Second World War – and especially the introduction of atomic weapons – instilled a new sense of fear, even repulsion, and an urgent need to bring the machine under control. Wilson and others, *The Machine Age in America*, p. 339.

36 See John R. Stilgoe, 'Moulding the Industrial Zone Aesthetic: 1880–1929', *Journal of American Studies* 16 (1982), pp. 5–24.

37 Waldon Fawcett, 'The Center of World Steel', *Century Magazine* 62 (May 1901), p. 190.

38 Stilgoe, 'Moulding the Industrial Zone Aesthetic', pp. 6–7.

39 Henry Adams, *The Education of Henry Adams* (Boston: Houghton Mifflin Co., 1918; reprinted 1973), p. 180. Of course, Adams himself was ambivalent about the American mind. See especially Ch. 25, 'The Dynamo and the Virgin', pp. 379-90.

40 Charles Caffin, 'Eduard J. Steichen's Work – An Appreciation', *Camera Work* 2 (April 1903), p. 24.

41 Birge Harrison, *Landscape Painting* (New York: Charles Scribner's Sons, 1909), p. 251.

42 See, for example, a passage in a contemporary story written by Temple Scott: 'Look at that Flatiron Building! There it is, stuck in the common rock. But, see, it mounts into heaven itself, a thing of beauty its sordid builders never dreamed of realizing. The sky has taken it unto itself as a part of its own pageantry. Let it be the symbol of your life.' Temple Scott, 'Fifth Avenue and the Boulevard Saint-Michel', *The Forum* 44 (December 1910), p. 684.

43 The official name of Stieglitz's gallery was 'The Little Galleries of the Photo-Secession'. It gained its nickname '291' because of its address. For Stieglitz's activities, see William I. Homer, *Alfred Stieglitz and the American Avant-Garde* (Boston: New York Graphic Society, 1977).

44 Quoted in Dorothy Norman, *Alfred Stieglitz: An American Seer* (New York: Random House, 1973), p. 45.

45 Wanda Corn, 'The New New York', *Art in America* 61
(July–August 1973), p. 59.

46 Donald Kuspit, 'Individual and Mass Identity in Urban Art:
The New York Case', *Art in America* 65 (September–October
1977), p. 68.

47 *Ibid.*

48 Corn, 'The New New York', p. 64.

49 John Marin, quoted in 'Notes on "291"', *Camera Work* 42–43
(April–July 1913), p. 18.

50 *Ibid.*

51 Quoted in 'The European Art-Invasion', *Literary Digest* 51
(27 November 1915), p. 1225.

52 Nerdinger, *Walter Gropius*, p. 14.

53 The official title of the show was the 'International Exhibition
of Modern Art'. It became known as the 'Armory Show' because
it was held in New York's Sixty-ninth Regiment Armory. See
Milton Brown, *The Story of the Armory Show* (New York:
Joseph H. Hirshhorn Foundation, 1963).

54 'Picabia, Art Rebel, Here to Teach New Movement', *New York
Times*, 16 February 1913, sec. 5, p. 9.

55 'A Post-Cubist's Impression of New York', *New York Tribune*,
9 March 1913, pt. 2, p. 1.

56 Quoted in 'The European Art-Invasion', p. 1224.

57 'French Artists Spur on an American Art', *New York Tribune*,
24 October 1915, sec. 4, p. 2.

58 Quoted in 'A Complete Reversal of Art Opinions by Marcel
Duchamp, Iconoclast', *Arts and Decoration* 5 (September 1915),
p. 428.

59 For the Arensbergs, see Francis Naumann, 'Walter Conrad
Arensberg: Poet, Patron and Participant in the New York
Avant-Garde, 1915–20', *Philadelphia Museum of Art Bulletin* 76
(Spring 1980), pp. 1–32.

60 Quoted in 'French Artists Spur on an American Art', p. 2.

61 Quoted in 'The Richard Mutt Case', *The Blind Man* 2 (May
1917), p. 5.

62 Paul Haviland, statement in *291* (September–October 1915),
unpaged.

63 This story was part of Schamberg's family tradition. William
C. Agee, *Morton Livingston Schamberg* (New York:
Salander-O'Reilly Galleries, 1982), pp. 10–11.

64 *Ibid.*, p. 14.

65 Earl A. Powell, III, 'Morton Schamberg: The Machine as Icon',
Arts Magazine 51 (May 1977), p. 123.

66 In about 1918, Schamberg produced a sculpture (assisted by
the notorious Baroness Elsa von Freytag Loringhoven) that
treated the theme of the machine with obvious irony similar
to the Dada expatriates. *God* (Philadelphia Museum of Art)
consists of an unsightly, tarnished plumbing trap attached to
a mitre box. This piece approaches the mocking tone of
Dadaist art, but *God* was an anomaly in Schamberg's career.

67 Quoted in Susan Fillin-Yeh, 'Charles Sheeler and the Machine Age' (Ph.D. diss., The Graduate Center, City University of New York, 1981), p. 81.

68 See Brown, *The Story of the Armory Show*, pp. 136–42.

69 Sheeler, autobiographical notes, Sheeler Papers, AAA, Roll NSh1, Frame 74.

70 Forbes Watson, *The New York Evening Post*, 23 January 1915, quoted in Patrick L. Stewart, 'The European Art Invasion: American Art and the Arensberg Circle, 1914–1918', *Arts Magazine* 51 (May 1977), p. 110.

71 Randolph Bourne, 'Our Cultural Humility', *Atlantic Monthly* 114 (October 1914), p. 506; also quoted in Matthew Baigell, 'American Art and National Identity: The 1920s', *Arts Magazine* 61 (February 1987), p. 48.

72 *The Forum Exhibition of Modern American Painters* (New York: Mitchell Kennerly, 1916), p. 5.

73 Baigell, 'American Art and National Identity', pp. 48–9.

74 Charles Sheeler to Alfred Stieglitz, 8 March 1918, Alfred Stieglitz Archives, Collection of American Literature, The Beinecke Rare Book and Manuscript Library, Yale University, New Haven, Conn.

75 Frederick S. Wight, 'Charles Sheeler', in *Charles Sheeler: A Retrospective Exhibition* (Los Angeles: Art Galleries, University of California, Los Angeles, 1954), p. 11.

76 Sheeler, autobiographical notes, Sheeler Papers, AAA, Roll NSh1, Frame 65.

77 Troyen and Hirshler, *Charles Sheeler*, p. 6.

78 See Karen Davies [Lucic], 'Charles Sheeler in Doylestown and the Image of Rural Architecture', *Arts Magazine* 59 (March 1985), pp. 135–6.

79 Agee, *Morton Livingston Schamberg*, p. 6.

80 See, for example, Horatio Greenough's discussion of American trotting wagons and yachts in *The Travels, Observations, and Experience of a Yankee Stonecutter* (Gainesville, Fl.: Scholars' Facsimiles & Reprints, 1958), p. 33.

81 Baigell, 'American Art and National Identity', pp. 48–51.

82 Joseph Stella, 'The Brooklyn Bridge (a page of my life)', *transition* 16/17 (June 1929), pp. 87–8.

83 Quoted in Friedman, *The Precisionist View*, pp. 34–5.

84 Charles Downing Lay, 'New Architecture in New York', *The Arts* 4 (August 1923), pp. 67–70. The editors of *The Arts* often commissioned Sheeler to produce photographs to illustrate articles during the early 1920s.

85 *Ibid.*, p. 67.

86 Lewis Mumford, 'The City', in *Civilization in the United States*, ed. Harold E. Stearns (New York: Harcourt, Brace & Co., 1922; reprinted, Westport, Conn.: Greenwood Press, 1971), p. 13.

87 Troyen and Hirshler, *Charles Sheeler*, p. 9.

88 The film was exhibited under various titles – *Mannahatta*, *New York the Magnificent*, and *La Fumée de New York*. See Jan-Christopher

Horak, 'Modernist Perspectives and Romantic Desire: Manhatta', *Afterimage* 15 (November 1987), pp. 8–9.

89 Stebbins and Keyes report that a photography exhibition in 1917 included one photograph of New York by Sheeler, which has now presumably been lost. Theodore E. Stebbins, Jr, and Norman Keyes, Jr, *Charles Sheeler: The Photographs* (Boston: Museum of Fine Arts, 1987), p. 7. To my knowledge, this is the only recorded image of New York City that Sheeler produced before *Manhatta*.

90 *Ibid.*, p. 18.

91 Peter Conrad, *The Art of the City: Views and Versions of New York* (New York: Oxford University Press, 1984), p. 80.

92 Quoted in *ibid.*, p. 103.

93 Stebbins and Keyes, *Charles Sheeler*, p. 17.

94 Quoted in *ibid.*

95 Quoted in Horak, 'Modernist Perspectives', pp. 11–12.

96 Stebbins and Keyes, *Charles Sheeler*, p. 19.

97 Quoted in Horak, 'Modernist Perspectives', p. 13.

98 Bram Dijkstra, *The Hieroglyphics of a New Speech: Cubism, Stieglitz, and the Early Poetry of William Carlos Williams* (Princeton: Princeton University Press, 1969), p. 103.

99 *Walt Whitman: Complete Poetry and Selected Prose*, ed. James E. Miller, Jr (Boston: Houghton Mifflin Co., 1959), p. 330.

100 *Ibid.*, p. 120.

101 *Ibid.*, p. 138.

102 Conrad, *The Art of the City*, p. 109.

103 Stebbins and Keyes, *Charles Sheeler*, pp. 18–21.

104 'Manhattan – "The Proud and Passionate City"', *Vanity Fair* 18 (April 1922), p. 51.

105 Stebbins and Keyes, *Charles Sheeler*, p. 21. The title by which the photograph is known today is convenient because it precisely identifies the subject, but it is not Sheeler's. He usually titled his urban subjects more generically – *New York* or *Skyscrapers*, for example.

106 Troyen and Hirshler, *Charles Sheeler*, p. 82.

107 *Vanity Fair* 15 (January 1921), p. 72.

108 *Ibid.*

109 Duncan Phillips, *A Collection in the Making* (New York: E. Weyhe, 1926), p. 65.

110 Troyen and Hirshler, *Charles Sheeler*, p. 80.

111 Van Wyck Brooks, *Letters and Leadership* (New York: B. W. Huebsch, 1918), pp. 2–3. The destruction of the urban fabric continued after Sheeler completed his image. The Sexton's Office has disappeared, and so, ironically, has Sheeler's monument to machine-age modernity – the Church Street El.

112 Quoted in 'A Complete Reversal of Art Opinions by Marcel Duchamp, Iconoclast', p. 428.

113 Georg Simmel, 'The Metropolis and Mental Life', in *On Individuality and Social Forms* (Chicago: University of Chicago Press, 1971), p. 325.

114 *Ibid.*, p. 326.

115 *Ibid.*, pp. 337–8.

116 John C. Van Dyke, *The New New York: A Commentary on the Place and the People* (New York: Macmillan Co., 1909), p. vii.

117 Waldo Frank, 'Vicarious Fiction', *The Seven Arts* 1 (January 1917), p. 294.

118 Quoted in Thomas Craven, 'Charles Sheeler', *Shadowland* 8 (May 1923), p. 71.

119 Quoted in Rourke, *Charles Sheeler*, p. 67.

120 See Schapiro, 'Nature of Abstract Art', pp. 193–5.

121 Simmel, 'The Metropolis and Mental Life', p. 332.

122 Charles Sheeler, 'A Brief Note on the Exhibition', in *Charles Sheeler: Paintings, Drawings, Photographs* (New York: Museum of Modern Art, 1939), p. 10.

123 Fillin-Yeh, 'Charles Sheeler and the Machine Age', p. 136.

124 Sheeler, 'A Brief Note on the Exhibition', p. 11.

125 For an in-depth analysis of this aspect of the artist's work, see Karen Lucic, 'The Present and the Past in the Work of Charles Sheeler' (Ph.D. diss., Yale University, 1989).

126 Karen Lucic, 'Charles Sheeler and Henry Ford: A Craft Heritage for the Machine Age', *Bulletin of the Detroit Institute of Arts* 65 (1989), p. 44. See also, Lucic, 'The Past and the Present in the Work of Charles Sheeler', especially Ch. 6.

127 Fillin-Yeh, 'Charles Sheeler and the Machine Age', p. 134.

128 See, for example, F. S. Lawrence, 'On the Passing of Delmonico's, an Architectural Landmark', *Architecture* 52 (November 1925), pp. 419–21.

129 George Sheppard Chappell, quoted in Robert A. M. Stern, Gregory Gilmartin, and Thomas Mellins, *New York 1930* (New York: Rizzoli, 1987), p. 7. The building has been known by a variety of names over the years. Today, it is simply '535 Fifth Avenue'.

130 Le Corbusier, for example, features grain elevators as one of America's most important architectural achievements. See Le Corbusier, *Towards a New Architecture*, trans. Frederick Etchells (London: Architectural Press, 1927; reprinted New York: Praeger, 1960), pp. 27–33.

131 Stern and others, *New York 1930*, pp. 7–8.

132 'On the Site of Historic Delmonico's', *Vanity Fair* 27 (November 1926), p. 72.

133 Fillin-Yeh, 'Charles Sheeler and the Machine Age', p. 214. Although a taller building did actually rise on the empty site shown in the foreground of *Delmonico Building*, it is not as high as the architect apparently anticipated, and the unadorned rear of Severance's skyscraper is still evident from Madison Avenue. Furthermore, the small buildings adjacent to it still stand today.

134 Van Dyke, *The New New York*, p. 102.

135 Conrad, *The Art of the City*, pp. 110–11.

136 *Ibid.*, p. 111.

137 Quoted in Susan Lubowsky, *George Ault* (New York: Whitney Museum of American Art, 1988), pp. 7, 18.

138 *Ibid.*, p. 7.

139 Stebbins and Keyes, *Charles Sheeler*, p. 22.

140 Charles Sheeler to Walter Arensberg, 10 January 1927, Charles Sheeler Papers, Arensberg Archives, Twentieth Century Department, Philadelphia Museum of Art.

141 Sheeler returned to New York as a subject in his work of the 1950s, however.

142 Henry McBride, 'Modern Art', *The Dial* 70 (February 1921), p. 235.

143 Simmel, 'The Metropolis and Mental Life', p. 337.

144 Thorstein Veblen, 'The Place of Science in Modern Civilisation', *The American Journal of Sociology* 11 (March 1906); reprinted in *The Place of Science in Modern Civilisation and Other Essays* (New York: B. W. Huebsch, 1919), p. 17.

145 Rosenfeld, 'Stieglitz', p. 401.

146 Brooks, *Letters and Leadership*, p. 22.

147 *Ibid.*, p. 46.

148 *Ibid.*, pp. 41–2.

149 *Ibid.*, pp. 20, 102, and 'On Creating a Usable Past', *The Dial* 64 (11 April 1918), p. 339.

150 Randolph Bourne, *Youth and Life* (Boston: Houghton Mifflin Co., 1913), p. 283.

151 Edward Abrahams, *The Lyrical Left: Randolph Bourne, Alfred Stieglitz, and the Origins of Cultural Radicalism in America* (Charlottesville, Va.: University Press of Virginia, 1986), pp. 38–9.

152 Alfred Stieglitz, 'Foreword', *The Forum Exhibition of Modern American Painters*, p. 35.

153 Rosenfeld, 'Stieglitz', p. 401. See also Abrahams, *The Lyrical Left*, pp. 98–9.

154 Herbert Croly, *The Promise of American Life* (New York: Macmillan Co., 1909; reprinted New York: Archon Books, 1963), p. 22; see also Abrahams, *The Lyrical Left*, pp. 5–6, 11–14.

155 Ling, *America and the Automobile*, p. 110.

156 Quoted in McLeod, '"Architecture or Revolution"', p. 134.

157 *Ibid.*, p. 137.

158 Le Corbusier, *Towards a New Architecture*, p. 264.

159 Henry Ford, 'Machinery – The New Messiah', *The Forum* 79 (March 1928), pp. 363–4.

160 *Ibid.*, p. 361.

161 Henry Ford, *My Life and Work* (New York: Doubleday, Page & Co., 1922), p. 103.

162 Gramsci, 'Americanism and Fordism', p. 303.

163 Jacob and Downs, *The Rouge*, p. 7.

164 *Ibid.*; Stebbins and Keyes, *Charles Sheeler*, p. 25.

165 Jacob and Downs, *The Rouge*, p. 11.

166 Sheeler to Arensberg, 25 October 1927, Arensberg Archives.

167 Stebbins and Keyes, *Charles Sheeler*, p. 33.
168 Many of these photographs are now lost; therefore, the precise extent of the series is not known. Jacob and Downs, *The Rouge*, p. 12.
169 *Ibid.*, p. 19.
170 In the 1920s, Lewis Hine was the only significant American photographer who depicted the human presence in the industrial environment. Naomi Rosenblum and Walter Rosenblum, 'Camera Images of Labor – Past and Present', in *The Other America: Art and the Labour Movement in the United States*, ed. Philip S. Foner and Reinhard Schultz (London: Journeyman Press, 1985), pp. 101, 111.
171 Ling, *America and the Automobile*, p. 138.
172 Stebbins and Keyes, *Charles Sheeler*, p. 27.
173 'By Their Works Ye Shall Know Them', *Vanity Fair* 29 (February 1928), p. 62.
174 Stebbins and Keyes, *Charles Sheeler*, p. 34.
175 Sheeler declined the invitation, feeling that the commission would interrupt the continuity of his artistic practice. Rourke, *Charles Sheeler*, p. 129.
176 Florence Kellogg, 'Order in the Machine Age', *Survey* 67 (March 1932), p. 589.
177 Allan Nevins and Frank Ernest Hill, *Ford: Expansion and Challenge, 1915–1933* (New York: Charles Scribner's Sons, 1957), pp. 573–88.
178 John Dos Passos, *The Big Money* (New York: Harcourt, Brace & Co., 1933), p. 56.
179 Jacob and Downs, *The Rouge*, pp. 47–52. The idea of commissioning the mural from Rivera originated with the museum's director, William Valentiner, but it was paid for by Edsel Ford, Henry's son, who was president of the Ford Motor Company at the time. The fact that a member of the managerial élite was willing to patronize Rivera's homage to American workers indicates how widely the Depression had affected expectations about the image of industry in American art. An enthusiastic and knowledgeable supporter of the arts (interestingly, he also purchased Sheeler's *Classic Landscape* during this period), Edsel Ford differed greatly in temperament from his more autocratic father, and indeed, he was unusual among corporate executives at the time.
180 Troyen and Hirshler, *Charles Sheeler*, p. 118.
181 Rourke, *Charles Sheeler*, p. 153.
182 Leo Marx, *The Machine in the Garden* (New York: Oxford University Press, 1964), pp. 355–6.
183 See Troyen and Hirshler, *Charles Sheeler*, p. 20, for an interesting discussion of Sheeler's presentation of the industrial environment as a new American wilderness, following in the footsteps of the Hudson River School painters a century earlier. Sheeler does adopt the horizontal format of the Hudson River School, at least in *American*

Landscape, but the smaller scale of his industrial scenes (usually less than 2′ × 3′) undercuts the comparison somewhat.

184 Williams, 'Charles Sheeler', in *A Recognizable Image: William Carlos Williams on Art and Artists*, ed. Bram Dijkstra (New York: New Directions Books, 1978), p. 144.

185 *Ibid.*

186 Williams, 'Foreword', in *Charles Sheeler: A Retrospective Exhibition*, p. 7.

187 A similarity in titles has led commentators such as Bram Dijkstra to assume that the poem is based on Sheeler's 1931 *Classic Landscape*. Dijkstra, *The Hieroglyphics of a New Speech*, p. 191. But Williams, because he mentions two smokestacks in the poem, obviously had another visual model in mind.

188 *The Collected Poems of William Carlos Williams*, vol. 1, ed. A. Walton Litz and Christopher MacGowan (New York: New Directions Books, 1986), pp. 444–5.

189 Williams, 'Foreword', in *Charles Sheeler: A Retrospective Exhibition*, p. 8.

190 *Ibid.*

191 Sheeler interview with Martin Friedman, 18 June 1959, AAA, pt. 1, p. 13.

192 Quoted in Wight, 'Charles Sheeler', p. 28.

193 *Ibid.*, p. 31.

194 At a lecture given in Cooperstown, New York, in 1987, I once casually remarked that Sheeler loved American industry. Dr William Amols, a former neighbour and friend of Sheeler's when the artist lived in Irvington-on-Hudson, approached me after the talk to correct me in this impression. Based on many conversations with the artist, Dr Amols concluded, 'Sheeler was in awe of American industry, but he didn't love it.'

195 Troyen and Hirshler, *Charles Sheeler*, pp. 164–74.

196 *Ibid.*, p. 172.

197 'Power: A Portfolio by Charles Sheeler', *Fortune* 22 (December 1940), pp. 73–4.

198 'Sheeler and Power', *Parnassus* 13 (January 1941), p. 46.

199 *Ibid.*

200 Troyen and Hirshler, *Charles Sheeler*, p. 170.

201 *Ibid.*, p. 172.

202 Charles Corwin, *New York Daily Worker*, 4 February 1949, p. 12, quoted in Martin Friedman, 'The Art of Charles Sheeler: Americana in a Vacuum', in *Charles Sheeler* (Washington, DC: National Collection of Fine Arts, 1968), p. 57.

203 Caption to illustration of Sheeler's *Incantation* (1946), *Fortune* 34 (November 1946), p. 127, quoted in Troyen and Hirshler, *Charles Sheeler*, p. 186.

204 Michael Kimmelman, 'An Iconographer for the Religion of Technology', *New York Times*, 24 January 1988, sec. H., pp. 29–30.

205 Baigell, 'American Art and National Identity', p. 51.

206 The Ford Motor Company, for example, did not sign a contract with unionized workers until 1941. Keith Sward, *The Legend of Henry Ford* (New York: Rinehart & Co., 1948), p. 419.

207 Charles Sheeler to Walter Arensberg, 6 February 1929, Arensberg Archives.

208 Advertisement for the Lincoln Motor Company, *Time* 12 (17 September 1928), p. 6.

209 Sheeler to Arensberg, 6 February 1929, Arensberg Archives.

210 Ling, *America and the Automobile*, pp. 4–5.

211 Brooks, *Letters and Leadership*, pp. 113–14.

212 Sherwood Anderson, 'A Great Factory: Problems and Attitudes in Life and Industry Considered from a Workman's Angle', *Vanity Fair* 27 (November 1926), p. 52.

213 See Frederic Jameson, 'Reification and Utopia in Mass Culture', *Social Text* 1 (Winter 1979), pp. 141–7, for an analysis of similar operations in popular entertainment like Hollywood films.

214 Paul Strand, 'Photography and the New God', *Broom* 3 (November 1922), p. 252.

215 *Ibid.*, p. 255.

216 *Ibid.*, p. 257.

217 Sheeler had established his studio in this building in 1930, shortly after it was erected. Carol Troyen, 'The Open Window and the Empty Chair: Charles Sheeler's *View of New York*', *The American Art Journal* 18 (1986), p. 25.

218 *Ibid.*, p. 28.

219 Charles Sheeler to Charles C. Cunningham, 7 April 1935, Paintings Department file, Museum of Fine Arts, Boston.

220 Quoted in Rourke, *Charles Sheeler*, p. 156.

221 For a more detailed analysis of this painting and its implications, see Lucic, 'Charles Sheeler and Henry Ford', pp. 37–47.

222 Susan Fillin-Yeh, 'Charles Sheeler's 1923 "Self-Portrait"', *Arts Magazine* 52 (January 1978), p. 108.

223 Fillin-Yeh has a much more upbeat reading of the picture, claiming that it asserts Sheeler's adherence to the impersonal mode of art-making and his positive identification with the machine. See *ibid*.

224 Sheeler, autobiographical notes, Sheeler Papers, AAA, Roll NSh1, Frame 123.

225 Troyen, 'The Open Window and the Empty Chair', p. 38.

226 Williams, 'Foreword', in Wight and others, *Charles Sheeler: A Retrospective Exhibition*, p. 7.

227 Fillin-Yeh, 'Charles Sheeler and the Machine Age', p. 112.

228 Quoted in Rourke, *Charles Sheeler*, p. 119. This passage is very close to one in Sheeler, autobiographical notes, Sheeler Papers, AAA, Roll NSh1, Frame 94.

229 Emily Genauer, 'Charles Sheeler in One Man Show', *New York World Telegram*, 7 October 1939, p. 34.

230 Fillin-Yeh, 'Charles Sheeler and the Machine Age', p. 164.

231 Walter Benjamin, 'The Work of Art in the Age of Mechanical Reproduction', in *Illuminations*, ed. Hannah Arendt (New York: Schocken Books, 1969), p. 221.

232 *Ibid.*, p. 220.

233 *Ibid.*, p. 234.

234 Sheeler, autobiographical notes, Sheeler Papers, AAA, Roll NSh1, Frame 109.

235 Craig Owens, 'Photography *en abyme*', *October* 5 (Summer 1978), p. 86.

236 Rosenblum and Rosenblum, 'Camera Images of Labor', p. 101; Troyen and Hirshler, *Charles Sheeler*, p. 188.

237 Sheeler interview with Bartlett Cowdrey, 9 December 1958, AAA, p. 23.

Chronology

1883 Charles Rettew Sheeler, Jr, is born on 16 July, son of
Charles Rettew Sheeler and Mary Cunningham Sheeler,
in Philadelphia, Pennsylvania. His father is employed by
the Clyde Line of Norfolk, a large steamship company.

1900 At the age of seventeen, Sheeler decides to become a
painter. With the support of his parents, he applies to
the Pennsylvania Academy of the Fine Arts. Discouraged
by the director of that institution, he instead enrols in the
three-year general course at the School of Industrial Art
in Philadelphia.

1903 Dissatisfied with the School of Industrial Art, Sheeler
once again attempts to enrol at the Pennsylvania
Academy, and this time is accepted. He studies still life
and life drawing under William Merritt Chase. Here he
meets fellow artist Morton Schamberg; between them
grows a profound friendship.

1904– Makes two trips to Europe under the tutelage of Chase:
1905 to Holland and London 1904 and Spain 1905.

1906 Graduates from the Pennsylvania Academy.

1908 Sheeler and Schamberg begin to share a studio on
Chestnut Street in Philadelphia. In November, New
York dealer William Macbeth exhibits five of Sheeler's
paintings. Between December and February, Sheeler
travels through Europe (Naples, Rome, Venice, Milan,
Florence, Paris) with his family and Schamberg. In Paris he
sees for the first time paintings by the vanguard: Cézanne,
Matisse, Braque, and Picasso, among others. This
experience causes Sheeler to reject the Impressionism of
Chase and to embrace European modernism.

1910 Sheeler continues to pursue his career as a painter in
Philadelphia. About this time, he and Schamberg rent
a house in Doylestown, in Bucks County, Pennsylvania,
for sketching on weekends. Sheeler and Schamberg also
take up commercial photography during this time to make
ends meet. Sheeler specializes in architectural
photography.

1911 Begins acquaintance with New York photographer and
gallery owner, Alfred Stieglitz.

1913 Exhibits six paintings in the Armory Show, New York.
The show makes a great impression on Sheeler and
further propels his work in the direction of abstraction.

1915	About this time, Sheeler begins to produce experimental photographs of Bucks County subjects.
1916	Exhibits nine paintings and drawings in the Forum Exhibition in New York. Begins to work as an assistant for Marius de Zayas at the Modern Gallery in New York.
1917	Sheeler's first exhibition of photographs at de Zayas's Modern Gallery. Photographs by Schamberg and Paul Strand are also shown. In December, Sheeler has a solo exhibition of Doylestown house photographs at the Modern Gallery.
1918	Sheeler's photographs appear in the thirteenth John Wanamaker photography exhibition; Sheeler wins first and fourth prizes with Doylestown subjects. On 13 October, Schamberg dies suddenly of pneumonia. Sheeler experiences shock and a deep sense of loss.
1919	Sheeler moves to New York. Although he keeps the Doylestown house until 1926, he visits there less frequently. Continues commercial photography to support himself, specializing in photographs of artworks. Later branches out into advertising and fashion photography. Sheeler's *Barn Abstraction* is reproduced in the New York Dada magazine *TNT*. Other artists featured include Man Ray, Marcel Duchamp, and Walter Arensberg.
1920	Solo exhibition of paintings, drawings and photographs at de Zayas's Modern Gallery. Makes an experimental seven-minute film, *Manhatta*, with Paul Strand, using unorthodox filming techniques. Strand and Sheeler focus on the skyscrapers of downtown New York. This is Sheeler's debut as iconographer of the machine age.
1921	Marries Katharine Baird Shaffer. His photographs begin to appear in *The Arts*, a periodical affiliated with the Whitney Studio Club.
1923	Sheeler writes a review of Stieglitz's work for *The Arts*, causing a permanent break in the two artists' friendship. Becomes the Whitney Studio Club's staff photographer and exhibition manager. Moves into an apartment above the Whitney Studio Club in Greenwich Village.
1924	Solo exhibition of paintings and drawings at the Whitney Studio Club.
1926	Through Edward Steichen, Sheeler secures a job as staff photographer at Condé Nast. His photographs appear regularly in *Vogue* and *Vanity Fair*. Holds the position until 1929. Also does freelance work during this period for several advertising agencies, including N. W. Ayer &

Son of Philadelphia. Sheeler and his wife move from New York to South Salem, New York, about forty miles north of Manhattan. Maintains a photography studio in New York City until 1932.

1927　Through Ayer, Sheeler receives commission to photograph Ford Motor Company's new River Rouge plant near Detroit. The project results in thirty-two 'official' photographs that are used for Ford's publicity purposes; they are also published in art journals throughout America, as well as in Europe and Japan. Sheeler continues as a freelance photographer for Ford until 1929.

1929　Takes his final trip abroad to view the *Film und Foto* exhibition in Stuttgart, Germany, which includes several of his photographs. Also visits Paris and photographs Chartres Cathedral.

1930–　Creates a series of paintings and conté crayon drawings
1932　of the River Rouge plant.

1931　Sheeler becomes affiliated with Edith Halpert's Downtown Gallery after his first solo exhibition there in November. In the same month, he shows his photographs in the inaugural exhibition of the Julien Levy Gallery.

1932　Moves with his wife to Ridgefield, Connecticut.

1933　Katharine Sheeler dies of cancer in June. Sheeler's mourning interrupts his artistic activity for several months.

1938　Constance Rourke publishes her biography, *Charles Sheeler: Artist in the American Tradition*, based on autobiographical notes Sheeler had written in 1937.

1939　Marries Musya Metas Sokolova. Travels through New York, Pennsylvania, Tennessee, Alabama and Nevada researching subjects for a series commissioned by *Fortune* magazine on the theme of power. The project results in six paintings reproduced in *Fortune*'s December 1940 issue. The Museum of Modern Art, New York, stages a major retrospective exhibition of Sheeler's paintings, drawings, and photographs.

1942　Moves for the last time, with his second wife, to Irvington-on-Hudson, New York. Begins work at the Metropolitan Museum of Art as Senior Research Fellow in Photography.

1945　After the war, Sheeler gives up his position at the Metropolitan Museum, devoting himself exclusively to painting.

1946	Works as artist-in-residence at Phillips Academy in Andover, Massachusetts.
1948	Works as artist-in-residence at the Currier Gallery in Manchester, New Hampshire, painting the abandoned nineteenth-century textile mills of Amoskeag Manufacturing Company.
1954	Retrospective exhibition of paintings, drawings, and photographs at the University of California, Los Angeles.
1959	Sheeler suffers a stroke in October which leaves him unable to paint or operate a camera.
1965	Sheeler suffers a second stroke and dies on 7 May.

Bibliography

SELECTED SOURCES ON SHEELER

Alfred Stieglitz Archives, Collection of American Literature, The Beinecke Rare Book and Manuscript Library, Yale University, New Haven, Conn.

'By Their Works Ye Shall Know Them', *Vanity Fair* 29 (February 1928), p. 62.

Charles Sheeler: Paintings, Drawings, Photographs, New York: Museum of Modern Art, 1939.

Charles Sheeler Papers, Archives of American Art, Smithsonian Institution, Washington, DC.

Charles Sheeler Papers, Arensberg Archives, Twentieth Century Department, Philadelphia Museum of Art.

Craven, Thomas, 'Charles Sheeler', *Shadowland* 8 (May 1923), pp. 11, 71.

'Cubist Architecture in New York', *Vanity Fair* 15 (January 1921), p. 72.

Fillin-Yeh, Susan, 'Charles Sheeler and the Machine Age', Ph.D. diss., The Graduate Center, City University of New York, 1981.

—— 'Charles Sheeler's 1923 "Self-Portrait"', *Arts Magazine* 52 (January 1978), pp. 106–9.

Friedman, Martin, and others, *Charles Sheeler*, Washington, DC: National Collection of Fine Arts, 1968.

Genauer, Emily, 'Charles Sheeler in One Man Show', *New York World Telegram*, 7 October 1939, p. 34.

Horak, Jan-Christopher, 'Modernist Perspectives and Romantic Desire: Manhatta', *Afterimage* 15 (November 1987), pp. 8–15.

Jacob, Mary Jane, and Linda Downs, *The Rouge: The Image of Industry in the Art of Charles Sheeler and Diego Rivera*, Detroit: Detroit Institute of Arts, 1978.

Kellogg, Florence, 'Order in the Machine Age', *Survey* 67 (March 1932), pp. 589–91.

Kimmelman, Michael, 'An Iconographer for the Religion of Technology', *New York Times*, 24 January 1988, sec. H, p. 30.

Lay, Charles Downing, 'New Architecture in New York', *The Arts* 4 (August 1923), pp. 67–70.

Lucic, Karen, 'Charles Sheeler and Henry Ford: A Craft Heritage for the Machine Age', *Bulletin of the Detroit Institute of Arts* 65 (1989), pp. 37–47.

—— 'Charles Sheeler in Doylestown and the Image of Rural Architecture', *Arts Magazine* 59 (March 1985), pp. 135–9.

—— 'The Present and the Past in the Work of Charles Sheeler', Ph.D. diss., Yale University, 1989.

'Manhattan – "The Proud and Passionate City"', *Vanity Fair* 18 (April 1922), p. 51.

'Power: A Portfolio by Charles Sheeler', *Fortune* 22 (December 1940), pp. 73–83.

Rourke, Constance, *Charles Sheeler: Artist in the American Tradition*, New York: Harcourt, Brace & Co., 1938.

'Sheeler and Power', *Parnassus* 13 (January 1941), p. 46.

Stebbins, Jr, Theodore E., and Norman Keyes, Jr, *Charles Sheeler: The Photographs*, Boston: Museum of Fine Arts, 1987.

Stewart, Patrick L., 'Charles Sheeler, William Carlos Williams, and Precisionism: A Redefinition', *Arts Magazine* 58 (November 1983), pp. 100–114.

Troyen, Carol, 'The Open Window and the Empty Chair: Charles Sheeler's *View of New York*', *The American Art Journal* 18 (1986), pp. 24–41.

Troyen, Carol, and Erica E. Hirshler, *Charles Sheeler: Paintings and Drawings*, Boston: Museum of Fine Arts, 1987.

Wight, Frederick S., and others, *Charles Sheeler: A Retrospective Exhibition*, Los Angeles: Art Galleries, University of California, Los Angeles, 1954.

OTHER SOURCES

Abrahams, Edward, *The Lyrical Left: Randolph Bourne, Alfred Stieglitz, and the Origins of Cultural Radicalism in America*, Charlottesville, Va.: University Press of Virginia, 1986.

Adams, Henry, *The Education of Henry Adams*, Boston: Houghton Mifflin Co., 1918; reprinted 1973.

Agee, William C., *Morton Livingston Schamberg*, New York: Salander-O'Reilly Galleries, 1982.

Anderson, Sherwood, 'A Great Factory: Problems and Attitudes in Life and Industry Considered from a Workman's Angle', *Vanity Fair* 27 (November 1926), pp. 51–2.

Baigell, Matthew, 'American Art and National Identity: The 1920s', *Arts Magazine* 61 (February 1987), pp. 48–55.

Benjamin, Walter, 'The Work of Art in the Age of Mechanical Reproduction', in *Illuminations*, ed. Hannah Arendt, New York: Schocken Books, 1969.

Bourne, Randolph, 'Our Cultural Humility', *Atlantic Monthly* 114 (October 1914), pp. 503–7.

—— *Youth and Life*, Boston: Houghton Mifflin Co., 1913.

Brooks, Van Wyck, *Letters and Leadership*, New York: B. W. Huebsch, 1918.

—— 'On Creating a Usable Past', *The Dial* 64 (11 April 1918), pp. 337–41.

Brown, Milton, 'Cubist-Realism: An American Style', *Marsyas* 3 (1943/45), pp. 138–60.

—— *The Story of the Armory Show*, New York: Joseph H. Hirshhorn Foundation, 1963.

Caffin, Charles, 'Eduard J. Steichen's Work – An Appreciation',
 Camera Work 2 (April 1903), pp. 21–4.
'A Complete Reversal of Art Opinions by Marcel Duchamp,
 Iconoclast', *Arts and Decoration* 5 (September 1915), pp. 427–8,
 442.
Conrad, Peter, *The Art of the City: Views and Versions of New York*,
 New York: Oxford University Press, 1984.
Corn, Wanda, 'The New New York', *Art in America* 61
 (July–August 1973), pp. 59–65.
Croly, Herbert, *The Promise of American Life*, New York: Macmillan
 Co., 1909; reprinted New York: Archon Books, 1963.
Dijkstra, Bram, *The Hieroglyphics of a New Speech: Cubism, Stieglitz,
 and the Early Poetry of William Carlos Williams*, Princeton:
 Princeton University Press, 1969.
Dos Passos, John, *The Big Money*, New York: Harcourt, Brace &
 Co., 1933.
'The European Art-Invasion', *Literary Digest* 51 (27 November
 1915), pp. 1224–5.
Fawcett, Waldon, 'The Center of World Steel', *Century Magazine*
 62 (May 1901), pp. 189–203.
Ford, Henry, 'Machinery – The New Messiah', *The Forum* 79
 (March 1928), pp. 358–64.
—— *My Life and Work*, New York: Doubleday, Page & Co., 1922.
—— 'My Philosophy of Industry', *The Forum* 79 (April 1928), pp.
 481–9.
The Forum Exhibition of Modern American Painters, New York:
 Mitchell Kennerly, 1916.
Frank, Waldo, 'Vicarious Fiction', *The Seven Arts* 1 (January 1917),
 pp. 294–303.
'French Artists Spur on an American Art', *New York Tribune*,
 24 October 1915, sec. 4, p. 2.
Friedman, Martin, *The Precisionist View in American Art*,
 Minneapolis: Walker Art Center, 1960.
Giedion, Siegfried, *Mechanization Takes Command*, London: Oxford
 University Press, 1948; reprinted New York: W. W. Norton, 1969.
Gramsci, Antonio, 'Americanism and Fordism', in *Selections from
 the Prison Notebooks of Antonio Gramsci*, ed. and trans. Quintin
 Hoare and Geoffrey Nowell Smith, New York: International
 Publishers, 1971.
Greenough, Horatio, *The Travels, Observations, and Experience of a
 Yankee Stonecutter*, Gainesville, Fl.: Scholars' Facsimiles &
 Reprints, 1958.
Harrison, Birge, *Landscape Painting*, New York: Charles Scribner's
 Sons, 1909.
Haviland, Paul, statement in *291* (September–October 1915),
 unpaged.
Homer, William I., *Alfred Stieglitz and the American Avant-Garde*,
 Boston: New York Graphic Society, 1977.
Jameson, Frederic, 'Reification and Utopia in Mass Culture', *Social
 Text* 1 (Winter 1979), pp. 141–7.

Josephson, Matthew, 'Henry Ford', *Broom* 5 (October 1923), pp. 137–42.

Kuspit, Donald, 'Individual and Mass Identity in Urban Art: The New York Case', *Art in America* 65 (September–October 1977), pp. 67–77.

Lawrence, F. S., 'On the Passing of Delmonico's, an Architectural Landmark', *Architecture* 52 (November 1925), pp. 419–21.

Le Corbusier, *Towards a New Architecture*, trans. by Frederick Etchells, London: Architectural Press, 1927; reprinted New York: Praeger, 1960.

Leuchtenburg, William E., *The Perils of Prosperity*, Chicago: University of Chicago Press, 1958.

Ling, Peter, *America and the Automobile: Technology, Reform and Social Change*, New York: Manchester University Press, 1990.

Lubowsky, Susan, *George Ault*, New York: Whitney Museum of American Art, 1988.

Lynd, Robert, and Helen Lynd, *Middletown: A Study in Modern American Culture*, New York: Harcourt, Brace & Co., 1929.

McBride, Henry, *The Flow of Art: Essays and Criticism of Henry McBride*, ed. Daniel Catton Rich, New York: Atheneum Publishers, 1975.

—— 'Modern Art', *The Dial* 70 (February 1921), pp. 234–6.

McLeod, Mary, '"Architecture or Revolution": Taylorism, Technocracy, and Social Change', *Art Journal* 43 (Summer 1983), pp. 132–47.

Mansbach, Steven A., *Visions of Totality: Lázló Moholy-Nagy, Theo Van Doesburg, and El Lissitzky*, Ann Arbor, Mich.: UMI Press, 1979.

Marx, Leo, *The Machine in the Garden*, New York: Oxford University Press, 1964.

Meikle, Jeffrey L., *Twentieth Century Limited: Industrial Design in America, 1925–1939*, Philadelphia: Temple University Press, 1979.

Meyer, Stephen, *The Five Dollar Day: Labor, Management, and Social Control in the Ford Motor Company, 1908–1921*, Albany: State University of New York Press, 1981.

Mumford, Lewis, 'The City', in *Civilization in the United States*, ed. Harold E. Stearns, New York: Harcourt, Brace & Co., 1922; reprinted Westport, Conn.: Greenwood Press, 1971.

Naumann, Francis, 'Walter Conrad Arensberg: Poet, Patron and Participant in the New York Avant-Garde, 1915–20', *Philadelphia Museum of Art Bulletin* 76 (Spring 1980), pp. 1–32.

Nerdinger, Winfried, *Walter Gropius*, Berlin: G. Mann Verlag, 1985.

Nevins, Allan, and Frank Ernest Hill, *Ford: Expansion and Challenge, 1915–1933*, New York: Charles Scribner's Sons, 1957.

Norman, Dorothy, *Alfred Stieglitz: An American Seer*, New York: Random House, 1973.

'Notes on "291"', *Camera Work* 42–43 (April–July 1913), p. 18.

'On the Site of Historic Delmonico's', *Vanity Fair* 27 (November 1926), p. 72.

Owens, Craig, 'Photography *en abyme*', *October* 5 (Summer 1978), pp. 73–88.

Phillips, Duncan, *A Collection in the Making*, New York: E. Weyhe, 1926.

'Picabia, Art Rebel, Here to Teach New Movement', *New York Times*, 16 February 1913, sec. 5, p. 9.

'A Post-Cubist's Impression of New York', *New York Tribune*, 9 March 1913, pt. 2, p. 1.

Powell, Earl A., III, 'Morton Schamberg: The Machine as Icon', *Arts Magazine* 51 (May 1977), pp. 122–4.

'The Richard Mutt Case', *The Blind Man* 2 (May 1917), p. 5.

Rosenblum, Naomi, and Walter Rosenblum, 'Camera Images of Labor – Past and Present', in *The Other America: Art and the Labour Movement in the United States*, ed. Philip S. Foner and Reinhard Schultz, London: Journeyman Press, 1985.

Rosenfeld, Paul, 'Stieglitz', *The Dial* 70 (April 1921), pp. 397–409.

Scott, Temple, 'Fifth Avenue and the Boulevard Saint-Michel', *The Forum* 44 (December 1910), pp. 665–85.

Schapiro, Meyer, 'Nature of Abstract Art', *Marxist Quarterly* (January–March 1937); reprinted in *Modern Art: 19th and 20th Centuries*, New York: George Braziller, 1978.

Seltzer, Lawrence H., *A Financial History of the American Automobile Industry*, Boston: Houghton Mifflin, 1928; reprinted Clifton, NJ: Augustus M. Kelley, 1973.

Simmel, Georg, 'The Metropolis and Mental Life', in *On Individuality and Social Forms*, Chicago: University of Chicago Press, 1971.

Stella, Joseph, 'The Brooklyn Bridge (a page of my life)', *transition* 16/17 (June 1929), pp. 86–9.

Stern, Robert A. M., Gregory Gilmartin, and Thomas Mellins, *New York 1930*, New York: Rizzoli, 1987.

Stewart, Patrick L., 'The European Art Invasion: American Art and the Arensberg Circle, 1914–1918', *Arts Magazine* 51 (May 1977), pp. 108–12.

Stilgoe, John R., 'Moulding the Industrial Zone Aesthetic: 1880–1929', *Journal of American Studies* 16 (1982), pp. 5–24.

Strand, Paul, 'Photography and the New God', *Broom* 3 (November 1922), pp. 252–8.

Sward, Keith, *The Legend of Henry Ford*, New York: Rinehart & Co., 1948.

Tsujimoto, Karen, *Images of America: Precisionist Painting and Modern Photography*, San Francisco: San Francisco Museum of Modern Art, 1982.

Van Dyke, John C., *The New New York: A Commentary on the Place and the People*, New York: Macmillan Co., 1909.

Veblen, Thorstein, 'The Place of Science in Modern Civilisation', *The American Journal of Sociology* 11 (March 1906); reprinted in *The Place of Science in Modern Civilisation and Other Essays*, New York: B. W. Huebsch, 1919.

Whitman, Walt: Complete Poetry and Selected Prose, ed. James E. Miller, Jr, Boston: Houghton Mifflin Co., 1959.

Williams, William Carlos, *The Collected Poems of William Carlos Williams*, vol. 1, eds. A. Walton Litz and Christopher MacGowan, New York: New Directions Books, 1986.

—— *A Recognizable Image: William Carlos Williams on Art and Artists*, ed. Bram Dijkstra, New York: New Directions Books, 1978.

Wilson, Richard Guy, Dianne H. Pilgrim, and Dickran Tashjian, *The Machine Age in America: 1918–1941*, New York: Brooklyn Museum in association with Harry N. Abrams, 1986.

List of Illustrations

Measurements are given in centimetres.

28 Charles Demuth, *Business*, 1921, oil. Art Institute of Chicago. Gift of Georgia O'Keeffe.

29 George Ault, *Construction Night*, 1922, oil. The Regis Collection, Minneapolis, MN.

30 Charles Demuth, *End of the Parade: Coatesville, Pa.*, 1920, tempera and pencil. The Regis Collection, Minneapolis, MN.

31 *Dahlias and Asters*, 1912, oil (51.1 × 57.9). Corcoran Gallery of Art, Washington, DC. Gift of Joan B. Detweiler.

32 *Skyscrapers*, 1922, oil (50.8 × 33.0). The Phillips Collection, Washington, DC.

33 *Church Street El*, 1920, oil (41.0 × 48.6). Cleveland Museum of Art. Mr & Mrs William H. Marlatt Fund.

34 *Upper Deck*, 1929, oil (74.0 × 56.3). The Fogg Art Museum, Harvard University. Louise E. Bettens Fund.

35 *Americana*, 1931, oil (121.9 × 91.4). Edith & Milton Lowenthal Collection, New York. (Photo: Brooklyn Museum)

36 *Classic Landscape*, 1928, watercolour, gouache and graphite (20.3 × 29.9). Collection of Barney A. Ebsworth.

37 *Classic Landscape*, 1931, oil (63.5 × 81.9). Collection of Mr & Mrs Barney Ebsworth Foundation.

38 *American Landscape*, 1930, oil (61.0 × 78.8). The Museum of Modern Art, New York. Gift of Abby Aldrich Rockefeller.

39 *River Rouge Plant*, 1932, oil (50.8 × 61.0). Whitney Museum of American Art, New York.

40 *City Interior*, 1935, oil (55.9 × 68.6). Worcester Art Museum, Worcester, MA.

41 *Production Foundry – Ford Plant*, 1927, photograph. Amon Carter Museum, Fort Worth.

42 *Power House No. 1 – Ford Plant*, 1927, photograph. University Art Museum, University of New Mexico. Gift of Eleanor and Van Deren Coke.

43 *Ladle Hooks, Open Hearth Building – Ford Plant*, 1927, photograph. From the Collections of Henry Ford Museum and Greenfield Village.

44 *Stamping Press – Ford Plant*, 1927, photograph. The Lane Collection, courtesy of the Museum of Fine Arts, Boston.

45 *Criss-Crossed Conveyors – Ford Plant*, 1927, photograph. Metropolitan Museum of Art, New York.

46 *Chartres Cathedral – Flying Buttresses at the Crossing*, 1929, photograph. The Lane Collection, courtesy of the Museum of Fine Arts, Boston.

47 *River Rouge Industrial Plant*, 1928, graphite and watercolour (20.3 × 28.6). Carnegie Museum of Art, Pittsburgh. Gift of G. David Thompson.

48 *Industrial Series # 1*, 1928, lithograph (20.7 × 28.3). Addison Gallery of American Art, Phillips Academy, Andover, MA.

49 *Smokestacks*, 1931, conté crayon (30.5 × 20.3). The Lane Collection, courtesy of the Museum of Fine Arts, Boston.

50 *Ballet Mechanique*, 1931, conté crayon (26.0 × 25.4). Memorial Art Gallery of the University of Rochester. Gift of Peter Iselin and his sister Emilie Wiggin.

51 Diego Rivera, *Detroit Industry, South Wall*, 1932–33, mural. Detroit Institute of Arts Founders Society Purchase, Edsel B. Ford Fund and Gift of Edsel B. Ford.

52 Detail of illus. 38, *American Landscape*.

53 *Primitive Power*, 1939, tempera (12.7 × 17.3). The Regis Collection, Minneapolis, MN.

54 *Wheels*, 1939, photograph. Smith College Museum of Art, Northampton, MA. Gift of Dorothy C. Miller.

55 *Manchester*, 1949, oil (63.5 × 50.8). The Baltimore Museum of Art. Edward Joseph Gallagher III Memorial Collection.

56 *Water*, 1945, oil (61.0 × 74.0). Metropolitan Museum of Art, New York.

57 Paul Strand, *Double Akeley*, 1922, photograph. Aperture Foundation, Inc., Paul Strand Archive.

58 *Yankee Clipper*, 1939, oil (61.0 × 71.2). Museum of Art, Rhode Island School of Design.

59 *Rolling Power*, 1939, oil (38.1 × 72.6). Smith College Museum of Art, Northampton, MA.

60 *Suspended Power*, 1939, oil (83.3 × 66.0). Dallas Museum of Art.

61 *Steam Turbine*, 1939, oil (55.9 × 45.7). Butler Institute of American Art, Youngstown, Ohio.

62 *Conversation – Sky and Earth*, 1940, oil (71.2 × 58.4). The Regis Collection, Minneapolis, MN.

63 *View of New York*, 1931, oil (121.3 × 92.1). Museum of Fine Arts, Boston.

64 *Home Sweet Home*, 1931, oil (91.4 × 73.7). Detroit Institute of Arts. Gift of Robert H. Tannahill.

65 *Cactus*, 1931, oil (114.6 × 76.4). Philadelphia Museum of Art. Louise and Walter Arensberg Collection.

66 *The Artist Looks at Nature*, 1943, oil (53.5 × 45.8). Art Institute of Chicago. Gift of the Society for Contemporary American Art.

67 *Self-Portrait*, 1923, conté crayon, gouache and pencil (50.0 × 65.4). Museum of Modern Art, New York. Gift of Abby Aldrich Rockefeller.

68 *Tulips*, 1931, conté crayon (74.9 × 57.8). Mr & Mrs James A. Fisher, Pittsburgh, PA.

69 *Interior with Stove*, 1932, conté crayon (72.39 × 52.07). Joanna T. Steichen. (Photo: Yale University Art Gallery)

70 *Amoskeag Canal*, 1948, oil (56.5 × 61.3). Currier Gallery of Art, Manchester, NH.